Bordered Lives

Bordered Lives
Transgender Portraits from Mexico

Kike Arnal

THE NEW PRESS

The authors and The New Press—recognizing that standards and preferences for the language terms used to refer to transgender identity and experience continue to evolve in Mexico, in the United States, and elsewhere—have made every effort in preparing the language for this book to respect the dignity of its subjects and the community that they represent.

Requests for permission to reproduce selections from this book should be mailed to:
Permissions Department, The New Press, 120 Wall Street, 31st floor, New York, NY 10005.

Published in the United States by The New Press, New York, 2014
Distributed by Perseus Distribution

ISBN 978-1-62097-024-9 (pbk)
ISBN 978-1-62097-055-3 (e-book)
CIP data available

The New Press publishes books that promote and enrich public discussion and understanding of the issues vital to our democracy and to a more equitable world. These books are made possible by the enthusiasm of our readers; the support of a committed group of donors, large and small; the collabo-ration of our many partners in the independent media and the not-for-profit sector; booksellers, who often hand-sell New Press books; librarians; and above all by our authors.

www.thenewpress.com

Book design and composition © 2014 by Emerson, Wajdowicz Studios (EWS)
This book was set in Helvetica Inserat, Helvetica Neue, Franklin Gothic and News Gothic

Printed in the United States of America

10 9 8 7 6 5 4 3 2 1

Preface
By Jon Stryker

The photographs in this book and future books anticipated in this series are part of a larger collective body of commissioned work by some of the world's most gifted contemporary photo-journalists. The project was born out of conversations that I had with Jurek Wajdowicz. He is an accomplished art photographer and frequent collaborator of mine, and I am a lover of and collector of photography. I owe a great debt to Jurek and his design partner, Lisa LaRochelle, in bringing this book series to life.

Both Jurek and I have been extremely active in social justice causes—I as an activist and philanthropist and he as a creative collaborator with some of the household names in social change. Together we set out with an ambitious goal to explore and illuminate the most intimate and personal dimensions of self, still too often treated as taboo: gender identity and expression and sexual orientation. These books will reveal the amazing multiplicity in these core aspects of our being, played out against a vast array of distinct and varied cultures and customs from around the world.

Photography is a powerful medium for communication that can transform our understanding and awareness of the world we live in. We believe the photographs in this series will forever alter our perceptions of the arbitrary boundaries that we draw between others and ourselves and, at the same time, delight us with the broad spectrum of possibility for how we live our lives and love one another.

We are honored to have Kike Arnal as a collaborator in *Bordered Lives*. He, and the other photographers among our partners, are more than craftsmen; they are communicators, translators, and facilitators of the kind of exchange that we hope will eventually allow all the world's peoples to live in greater harmony. ■

Prologue

By Guillermo Osorno

Translated by Lawrence Schimel

On May 17, 2008, while representatives of Mexico City's Legislative Assembly debated a modification to the Civil Code that would allow transgender people to secure legal recognition of their gender, Mario and Diana (who appear in this book) got married. Mario, a retired prison guard, is a transgender man, and Diana, an engineer, is a transgender woman. Mario and Diana had taken part in the meetings, forums, and assemblies prior to the approval of the law, so when they announced their plans to get married, the media took note and covered the wedding extensively. The invitation to the ceremony was a political declaration. It read: "Come to our wedding and support us with your presence. It is believed that out of every 35,000 births in this world, a child will be born with the identity contrary to their physical body; in this way a boy will behave like a girl and a girl like a boy. This condition of life is known as transsexuality. Due to the legal vacuum that prevents transgender people from using their chosen names, this wedding will take place with our official names, which are: María del Socorro Sánchez for Mario and José M. Guerrero for Diana. We hope in the future to correct this incongruence through the approval of the proposed law for legal recognition of transsexuals and transgender people." The wedding appeared in all the newspapers and on many television channels. People began to recognize Mario and Diana on the street and ask to have their pictures taken with them. They became a symbol of the transgender community in Mexico.

In the middle of July 2014, I visited Diana in the Mexico City Attorney General's Office where she works; Mario was with her. Diana is a fortysomething-year-old woman, very neatly dressed, who behaves with great restraint. Mario, on the other hand, is jovial, speaks quickly, and is full of anecdotes. They told me that after their wedding, when the modifications to the Civil Code were finally approved in 2009, they could at last change their names and genders.

The reforms to the Civil Code, however, can be problematic. They establish, among other things, that legal sex reassignment must be made through a lawsuit after the person has obtained concordance "between the bodily aspects and their gender identity" through the administration of hormones, psychotherapy, or surgery. This process proves to be cumbersome and costly, not just because of the medical procedures involved but also because of the legal fees, which run between thirty and fifty thousand pesos (roughly two and four thousand dollars). Many people, moreover, do not wish to subject themselves to the complete transformation. Now, activists are campaigning for the procedure of sex reassignment to be a mere administrative procedure; this modification to the law will be debated in the second half of 2014.

As with everything, the reforms to the Civil Code are a sign of how the transgender community in Mexico has evolved in recent years; Kike Arnal's book of photographs profiles this diversity. It shows the intimate stories of six people, who the photographer contacted through websites and Facebook. Arnal set himself the task of portraying their transitions. Angie is a fiftysomething-year-old transgender woman who was twice married as a man, had two children, came out of the closet, got divorced, and now lives her life openly as a woman, but without her family. Himmel is a very pretty chorus girl who has appeared in films and on television. At fourteen, Jessica told her mother that she wanted to be a girl and received her mother's approval and support; she is currently completing her college degree. Oyuki was a sex worker; she adopted a daughter approximately ten years ago and earned a degree in political science from a public university, but continues to work the streets. Mario and Diana are a couple who are the symbol of the community. Some of Arnal's photographs emphasize the different aspects of living as a transgender person—getting dressed and doing makeup—while other photographs reflect the fact that sex reassignment is an ongoing process because the majority of transgender people in Mexico cannot have costly medical procedures due to a lack of financial resources.

The other day, I was having lunch with Arnal and a mutual friend, Ximena de la Macorra. I asked Arnal what lessons he had learned from his work with Mexico's transgender community. He told me that, at first, the country's morality seemed quite closed to him, but later he found that the matter was much more open than it seemed, and that the middle and lower classes of society, where he was working, were much more tolerant.

Perhaps the most-documented transgender community of Mexico are the *muxes* of the Isthmus of Tehauantepec. Since the pre-Colombian period, the Zapotec community in Oaxaca has recognized the existence of a third gender: men who carry out female roles. They dress as women in the showy outfits of the region, clean houses, embroider, cook for festivals, and are in charge of the sexual initiation of the young people in the community. The only condition for their community acceptance is that they not have a partner of their own so that they can care for the elderly. They hold an annual party or Vela (named because *velas*—"candles"—are lit) called the *Muxe* Celebration of the Authentic Fearless Seekers of Danger. They put on a drag show and crown a beauty queen. It is a fabulous spectacle that is unique in the world.

In recent years, Mexican documentary filmmakers have become interested in the subject. The cineaste Jacaranda Correa filmed the story of Irina Layevska, a transgender woman who grew up in the heart of a communist family, in the film *Morir de Pie* (Die Standing Up). As a child, Layevska showed symptoms of Charcot-Marie-Tooth, a disease which provokes muscular atrophy in the legs and arms, and had to undergo painful operations. As a youth, she strongly supported the Fidel Castro government and lived in Cuba during the Special Period. There, she married a Mexican woman named Nélida. At the beginning of the 2000s, her illness grew worse; faced with the evidence that she could become blind, she suffered a new crisis that made her confront her true identity, and she began a sex change. Nélida supported the changes and although she had doubts about her love for Irina, who had become a woman, she remained faithful; she takes care of Irina, who is now almost blind and in a wheelchair.

In 2014, Roberto Fiesco's film *Quebranto* won the Ariel Award for Best Documentary, the prize given by the Mexican Academy of Film. *Quebranto* tells the story of Coral Bonelli, a child actor in Mexican films who becomes a woman, and her ancient mother. It is a splendid study of filial love.

In the Mexican academic field, transgender studies have become more common. The historian Gabriela Cano, for example, has written about Amelio Rosas, a woman who dressed as a man in order to take part actively in the Mexican Revolution. Afterward, Amelio led a life as a retired military man, receiving the honors and decorations reserved only for men, even though everyone knew that Amelio was a woman. The anthropologist Marta Lamas, editor of the country's most important feminist magazine, *Fem*, wrote a postgraduate thesis titled "Transsexuality: Identity and Culture," which records how many transgender people represent and communicate their problems. There are ethnographies about transgender communities in Mexico City and studies about the process of legal recognition and about transgender sex work, among many other recent investigations.

The Internet obviously has changed the transgender community enormously. Forums, web pages, and blogs have done extraordinary work promoting transgender awareness in Mexico. In terms of activism, the transgender community has been organized since the 1990s, although not always in a continuous fashion. There have always been two strands of online activism: one focused on political organizing, and a more social one focused on organizing parties. Transgender

organizations were very active in 2008, when modifications to the Civil Code were debated, and they have again become very active in 2014, with the initiative to simplify the procedure of legal recognition. The Mexican Institute of Sexology, an academic center, has also been fundamental in the construction of the movement's intellectual framework.

The community has its political heroes and heroines, such as Lola Deja Vu, general coordinator of the sex worker movement, who advocates not just for rights for the transgender sex work community, but who has also become one of the principal voices defending the intermediary processes of sexual transition. Gloria Hazell Davenport is another leader with a long trajectory. A graduate of a communications school, she was a public servant before her transition. She is one of the most direct and articulate voices of the community, and is now joined by Diana Sánchez Barrios, who deserves her own special mention. Diana is the daughter of one of the most powerful leaders of street vendors in the city center. Her leadership offers a considerable number of votes, and she is about to become the first transgender person in Mexico City's Legislative Assembly. She has an organization called, quite conveniently, Pro Diana, and it is one of the main driving forces of the simplification of the process of legal recognition in Mexico City. Another person, Roshell, runs a bar in a middle-class Mexico City neighborhood that also functions as a community center, where many male cross-dressers learn to put on makeup, dress, and be women.

For Diana and Mario, it seems that many things have changed in Mexico, but there is still a lot left to do. The majority of these changes are localized in Mexico City; life for the transgender community in the rest of Mexico continues to be very complicated. It's true that there is a new institutional structure, committees to prevent discrimination, and governmental regulations to address gender diversity, but very little of this has permeated into general society. Many transgender people continue turning to sex work because they cannot get another job. Organizations in the civil sector operate in a precarious fashion because they have almost no money. "What use is it to change a person's birth certificate if when they go to apply for a job they're going to be rejected?" Diana said. "Sensitization must now be aimed at society in general. We are doing what we can." ▪

Introduction
By Susan Stryker

The presence of the U.S. border with Mexico is palpable in Tucson, where I direct the Institute for LGBT Studies at the University of Arizona. It lies only several dozen miles to the south. It's an hour by car on the interstate if you're one of those lucky people, documents in hand, who will be waved across it, and days on foot across the Sonoran Desert if you are not. That way of crossing, too, involves a share of luck, as the remains of unlucky others attest—those four hundred or so who find their way to the Pima County Medical Examiner's Office each year, as well as those who lie scattered, uncounted, along the routes of passage.

This is the border that I, perhaps like many others reading this book, must literally and figuratively look across to encounter the transgender subjects Kike Arnal has photographed in Mexico City. Although I am a transwoman myself, and a transgender studies scholar, I can't pretend that their lives and mine are necessarily alike. I am a tourist in the spaces represented in this book, a white monolingual English-speaker, a citizen of the United States who has spent little time in Mexico apart from border towns and holiday resorts. How do my social positioning and linguistic shortcomings inform what I can see, what connections I can make? On the other hand, what might I, who am transsexual, see that Arnal, who is not, may be unaware of having recorded with his camera? What aspects of trans lives in Mexico might he, a New York–based Venezuelan, misperceive, in spite of sharing a Latino culture, that I as a trans person might recognize or know how to read against the grain of his outsiderness to trans experience?

The acts of looking that take place in this book start from many locations, and the acts of crossing it take place in many registers, across many lines of separation. I am curious, and curiosity is okay. I want to look and to look at looking; I want to see the faces of others looking back and to learn.

As the poet Gloria Anzaldúa famously noted, the border between the United States and Mexico is a 2,000-mile-long scar, a place where the Third World rubs against the First World and bleeds. Near Tucson, the border fence rears its steel pylons twenty feet up from the surface of the earth, a line of surgical staples running across the brown belly of North America, suturing shut what might otherwise be an open space of possibility, dividing this land against itself even while connecting it to other places with equally fraught histories. Palestine. Korea. Berlin. Is this the sort of border Arnal has in mind when he speaks of "bordered lives," a geo-political border delimiting the body politic to which his photographic subjects belong? Or does he mean something else, something metaphorical? How might all of our lives carry borders with them, wherever they go, wherever they remain—borders of class, ethnicity, nationality, language, gender?

I have a hard time seeing the people Arnal shows me without looking across this violent landscape. I think of the Jesuit father at the border refuge in Nogales who told me he ministered to two or three *transgenero* migrants a week, and of the trans and queer former detainees I've met through the Rainbow Defense Fund, which raises money to free LGBT people held in the Florence and Eloy immigration detention facilities in southern Arizona. I think, too, of my friend O., a gay Latino man who fled his home country after being brutally assaulted, raped, and threatened with murder by the police officers who stopped him and his friend as they were driving to a nightclub in drag. Of the economics professor from a northern Mexican university, a heterosexual feminist who came to visit me in my office in Tucson, wanting to know how she could set up support services for LGBT students on her campus, a responsibility she felt compelled to take on because all of her gay and lesbian faculty colleagues were too afraid of

the consequences of being open about their sexuality. It would be easy to assume, based on these experiences, that Mexico is a place that trans and queer people want to escape—even if it remains difficult to believe, given so much evidence to the contrary, that the United States offers a truly safe haven.

The first great strength of Kike Arnal's *Bordered Lives* then is simply that it documents livable transgender lives in Mexico. Succeeding at living while trans is itself a triumph, a demonstration of the inalienable worthiness of any life, in a country where 106 trans people were murdered in 2013, the last year for which statistics are available from the Transgender Murder Monitoring Project.

The people we see in Arnal's photographs—Angie, Génesis, Oyuki, Mario and Diana, Himmel, Jessica—are living well. They are rooted firmly enough in their worlds to withstand the many prejudicial pressures that might end their lives or rip them from the social fabric, perhaps setting them on a northward path, along with so many others who need to cross the border to secure their means of life. Like us all, the people in Arnal's photographs make a daily life in the face of dangers, risks, and uncertainty; as we can all aspire to emulate, they do so with a graceful, quietly persistent power.

In *Bordered Lives,* we see trans people conducting themselves purposefully, engaging in meaningful activity to earn a living, giving to their communities, connecting to lovers and family, enjoying the pleasures of their bodies, taking satisfaction in their appearance, knowing themselves, addressing the camera with an air of confidence. They show us their strength through their willingness to become vulnerable, sharing intimate details of transformation and self-care—scenes of dressing, injecting, depilating, the sights (and sites) of surgical scars—that might undermine, in the eyes of others, the reality of their achieved sense of a gendered self. They are trans people who cannot be defined solely by their trans status. They are people who

live in neighborhoods, who have friends. They are college students and taxi drivers, government workers and employees of nongovernmental organizations, prostitutes and entertainers. They are people with whole lives, who allow us to witness a small sliver of those lives.

I am old enough to remember a time when most mass-media representations pathologized, stigmatized, condemned, derided, exoticized trans people. At best they patronized and conde-scended. We've come a long way since then, as this book demonstrates, and have broadened considerably the scope of what it is now permissible to show, to see, to relate to, to under-stand, in transgender lives. But still I wonder sometimes why non-transgender people are so fascinated with watching transgender people change clothes, take medicine, groom, go down the street. Doesn't everybody do these things? What's the big deal? It's not like watching a monkey doing math. (Or is it?)

Then I remember that even in images of such quotidian behaviors others can still see a peculiar kind of agency. They can see people taking charge of the meaning of their own bodies. They can see people appropriating commonly understood representations of masculinity and femininity in order to express themselves in ways that feel right, rather than simply being the men or women that society, church, and state tell them they ought to be, even if it feels wrong. They can see a different way of being manifest itself, in the flesh, and thereby know that real change is possible. If, through the flare of hypervisibility that often surrounds trans bodies, others can witness a potential for things being otherwise than they are, then perhaps it is worth our being looked at. Perhaps that is our gift.

I hope, when you look through Kike Arnal's lens at these ordinary and extraordinary people, that this is what you see looking back at you, soliciting you: the power of radical self-transformation, the power to begin changing the world from where one stands. ▪

Angie Rueda Castillo

ANGIE RUEDA CASTILLO IS AN ACTIVIST FROM MEXICO CITY. SHE STUDIED SOCIOLOGY AT UNIVERSIDAD IBEROAMERICANA, ONE OF THE MOST PRESTIGIOUS PRIVATE UNIVERSITIES IN MEXICO.

Angie received a master's degree and has taught at her alma mater, as well as in other colleges and universities in Mexico.

Living as a young man, Angie, who is now in her fifties, never suspected her transgender condition (as she defines it). She never played with dolls or dressed as a woman while a child or teen. Eventually, Angie married twice, and had two children, now teenagers, during her second marriage.

In 1999, Angie discovered her gender identity. In 2004, after ten years of living with her wife and two children, Angie left her home due to domestic violence against her because of this revelation. The awakening of her sexual identity and the transition from male to female became an irresolvable conflict with her wife. Since her divorce several years ago, it has been extremely difficult for Angie to see or talk to her children. The last time she saw them in person was in 2011.

Angie writes emails to her sixteen-year-old daughter once or twice every week but she has not communicated with her son in several years. This situation is extremely painful for her.

Angie is a strong advocate and participatory activist in the LGBT movement. In 2007, Angie was a founding member of the *Frente Ciudadano Pro Derechos de Transexuales y Transegéneros* or *Frente Trans* (Caring Front for the Rights of Transsexuals and Transgender People or Trans Front). In 2011, Angie published her autobiography titled *Hola, soy Angie*.

Angie is a practicing Catholic and political leftist who believes in social justice. As of 2014, Angie is going through hormonal replacement treatment and aspires eventually to have sex reassignment surgery. She hopes to complete the process by the time she is sixty years old.

"I don't hate the man I was, he gave me what I love the most in my life: my daughter and my son."

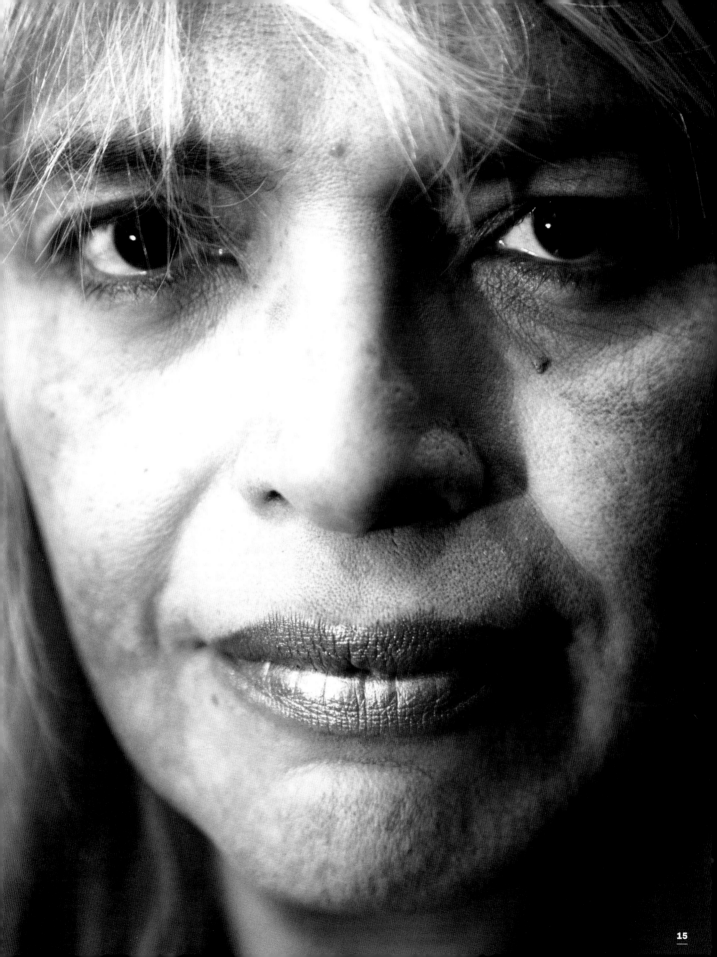

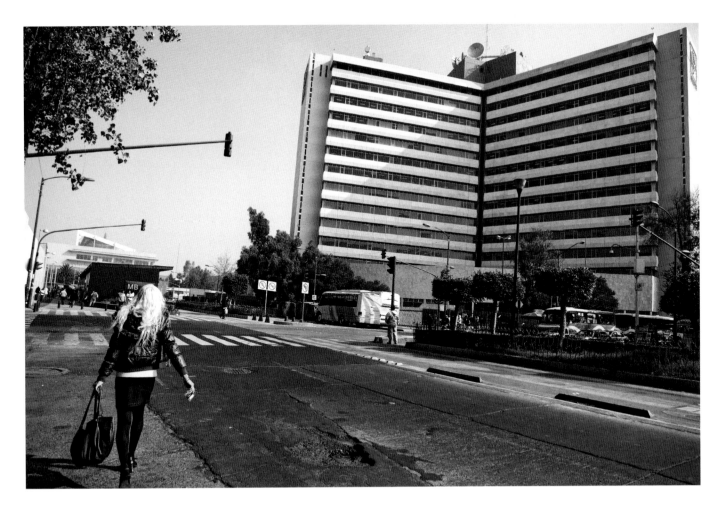

Angie approaches the Institute for Social Security and Services for State Workers (ISSSTE) building where she has worked since 2009 in the human rights area.

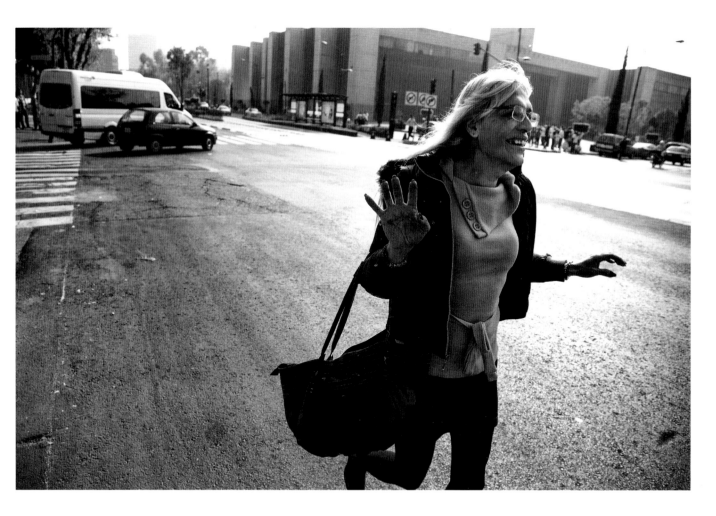

Tall and blond, Angie walks every morning to the Tasqueña metro station.

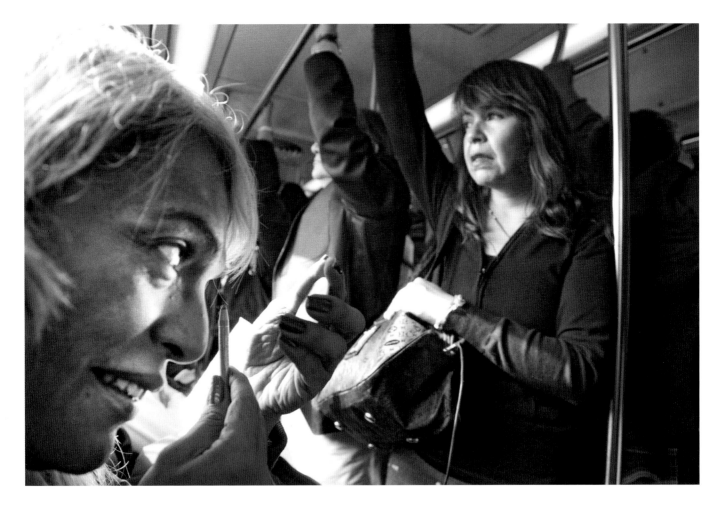

Angie applies makeup while riding to work by metro.

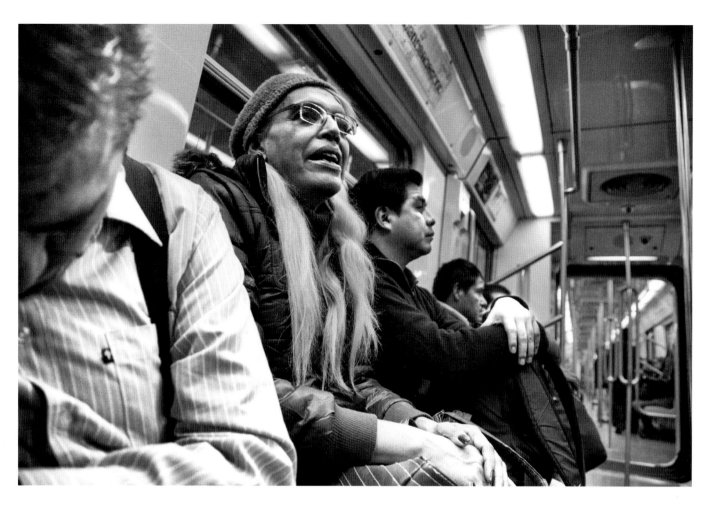

Angie rides the subway home after a long day.

Very early in the morning, Angie eats breakfast by herself before leaving for her job at ISSSTE. It takes Angie over an hour to go from Tasqueña, where she lives, to downtown Mexico City.

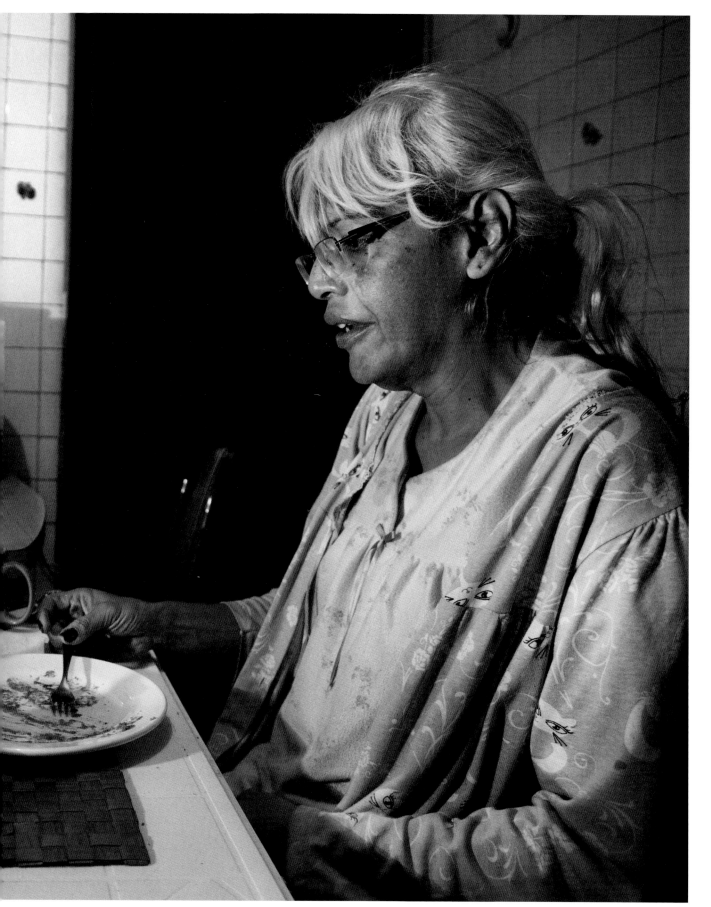

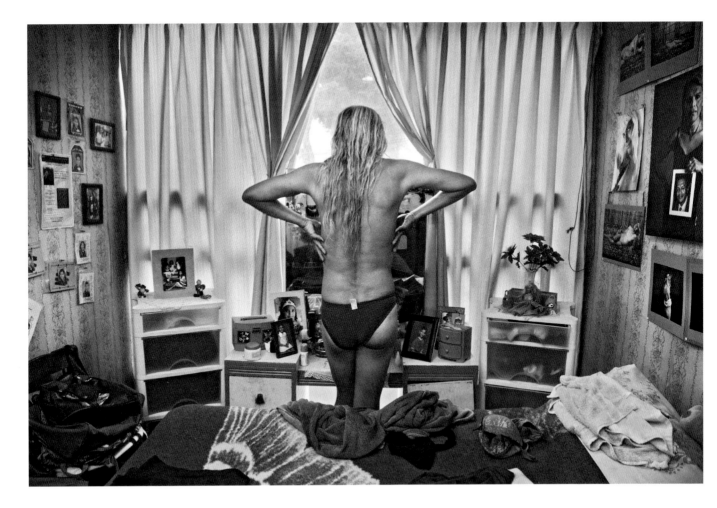

Getting dressed is an everyday joy for Angie.

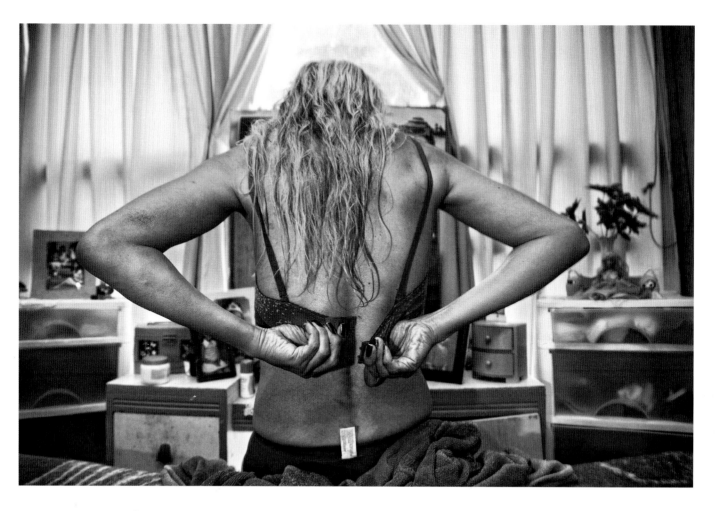

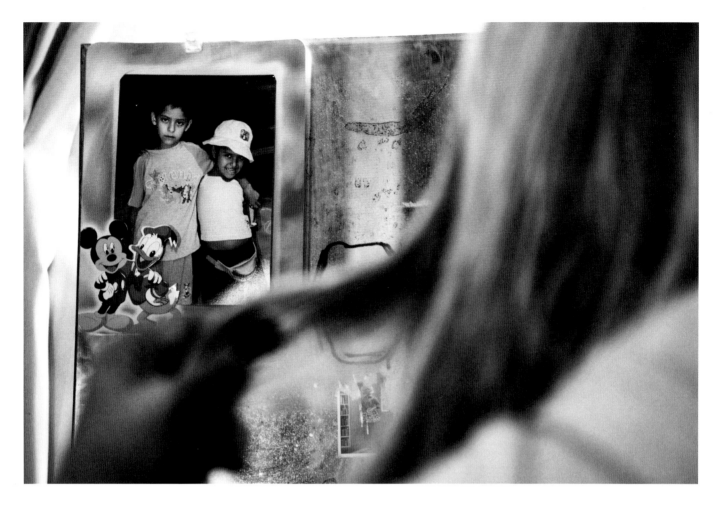

Angie combing her long hair before the pictures of her two beloved children.

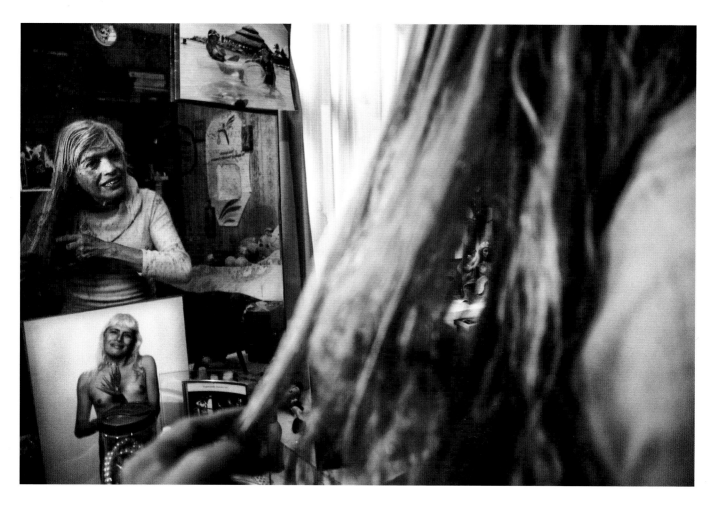

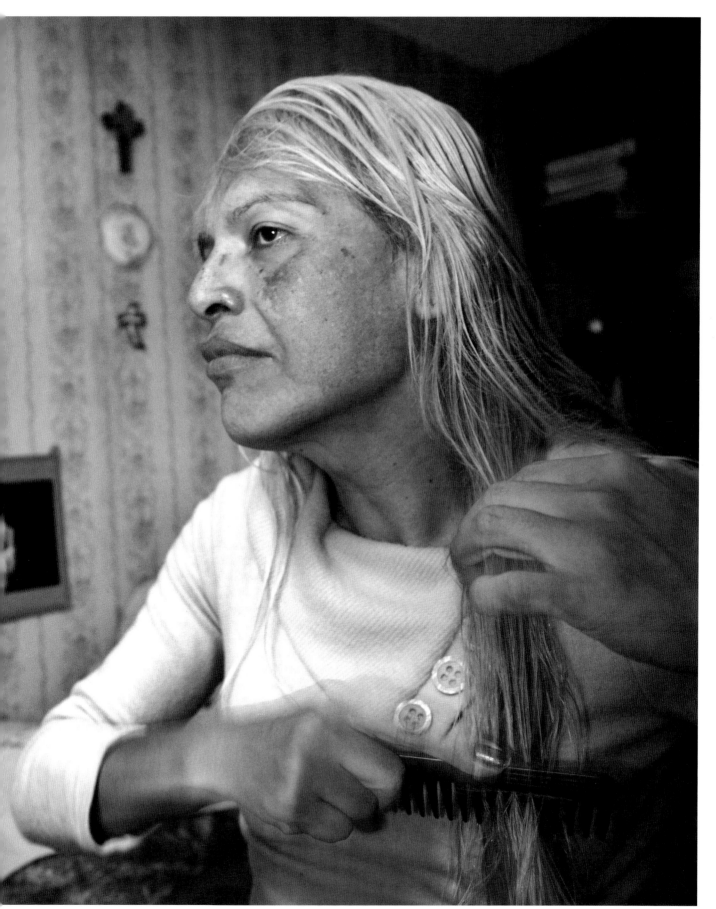

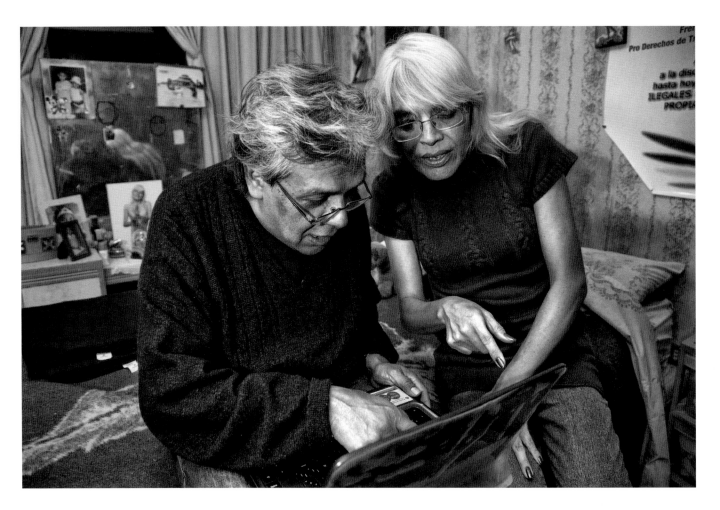

Angie shares time with her brother. As a child, Angie's only link to femininity was through her mother, grandmother, and sister. Today she maintains a very close relationship with her brother.

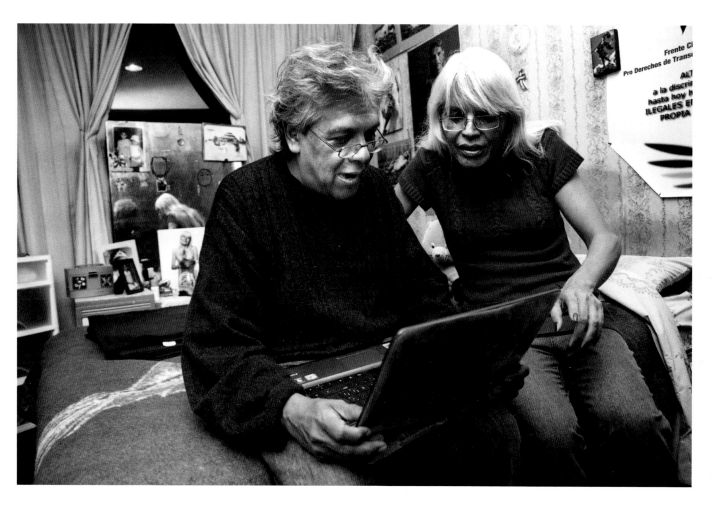

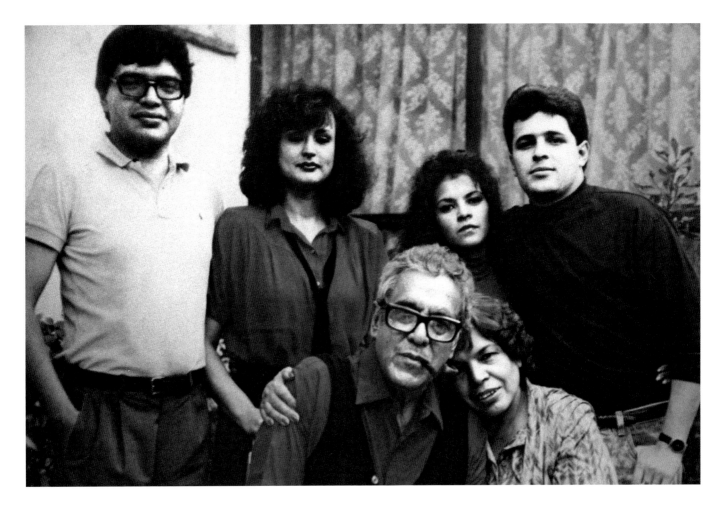

A picture of Angie (left) with her first wife. Her father, sister, and brother–in–law appear in this photo as well.

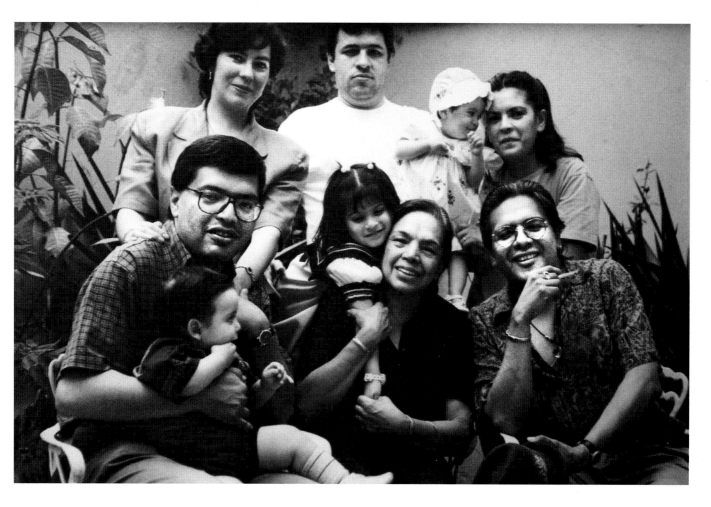

Old photograph of Angie as a young father with her family. Angie (left) holds her son Paco on her lap; her second wife is behind her. The others in the photograph are her mother, sister, niece, and brother–in–law.

Before leaving for work in the morning, Angie kisses a photograph of her son. She has not seen him since 2011.

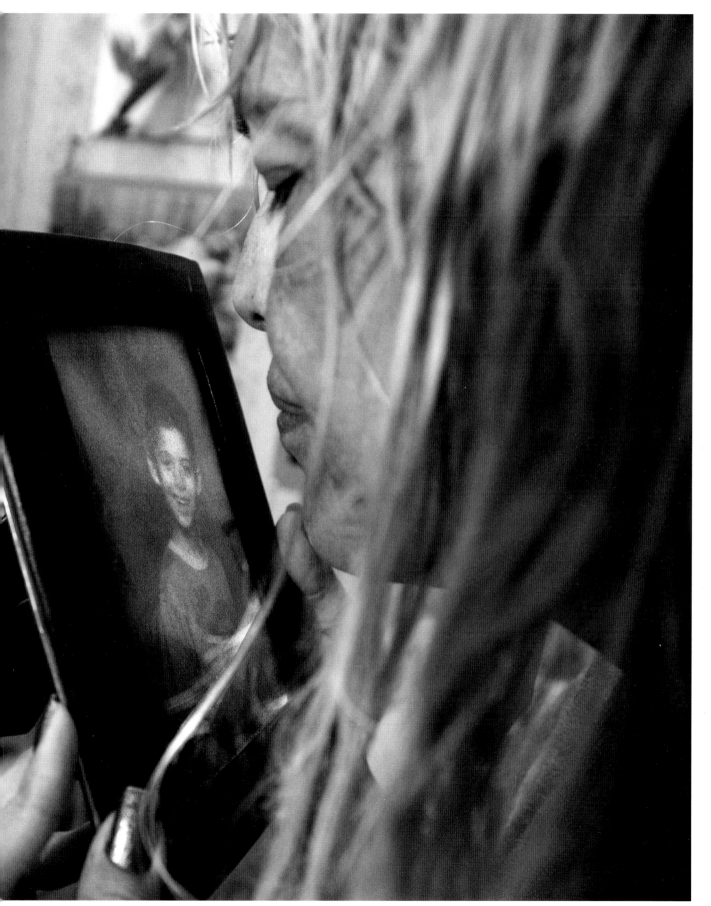

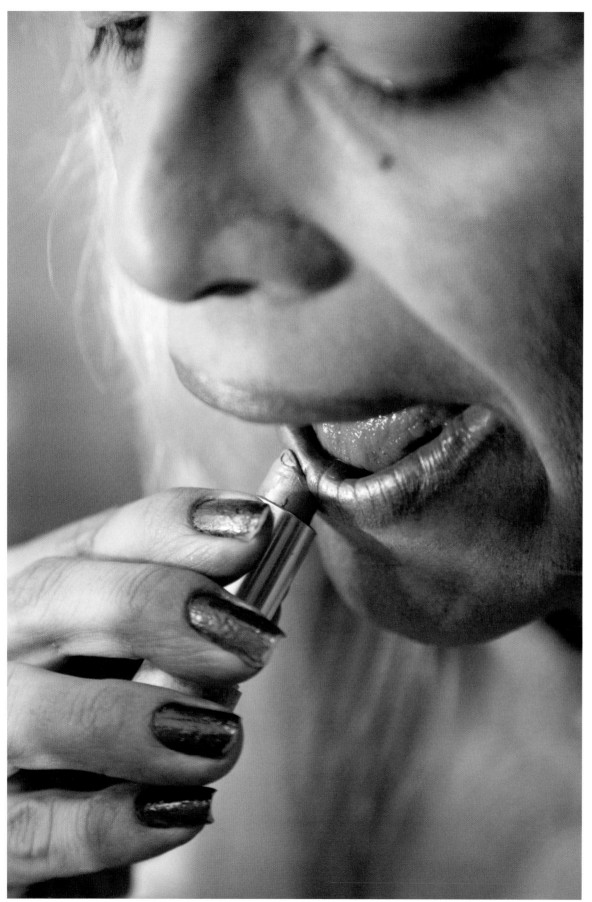

Angie walking on Madero Street in downtown Mexico City. In 2007, Angie was a founding member of the *Frente Ciudadano Pro Derechos de Transexuales y Transegéneros* or *Frente Trans*.

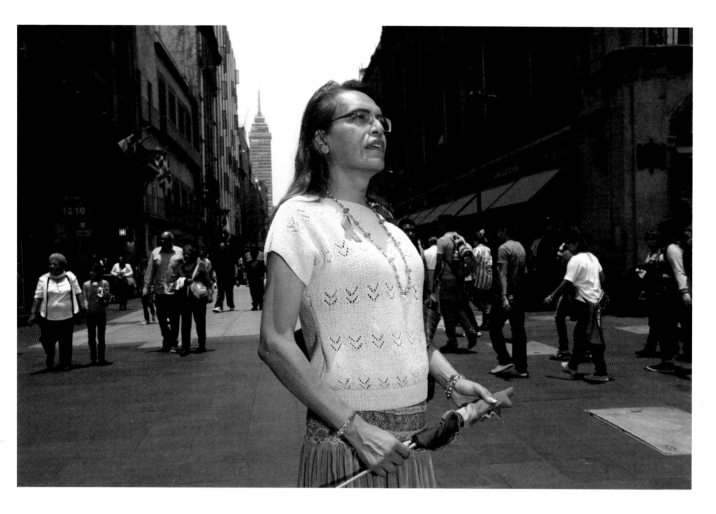

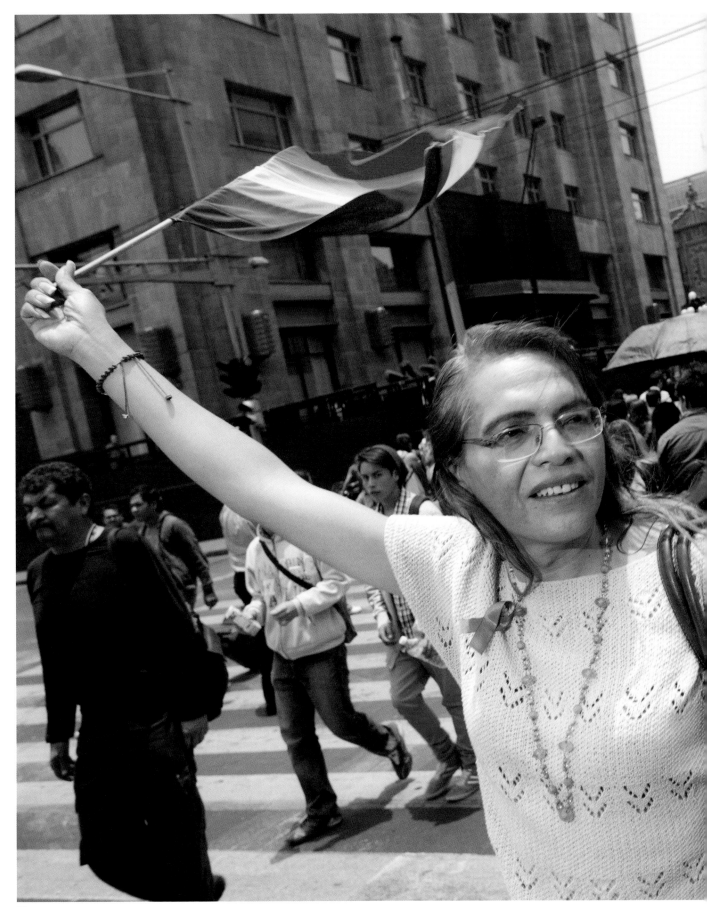

Génesis Rafael Lopez Ramirez

GÉNESIS IS THIRTY-NINE YEARS OLD. ORIGINALLY FROM A SOCIALLY CONSERVATIVE CITY IN THE STATE OF GUANAJUATO IN CENTRAL MEXICO, GÉNESIS REALIZED THAT HE WANTED TO LIVE AS A MAN FROM A VERY EARLY AGE.

He remembers, "In kindergarten, we were formed into two lines to show us the bathrooms and I positioned myself in the boys' line until the teacher took me out of it and moved me to the girls' line." Acting as a boy caused difficulties for Génesis as a child; he was verbally harassed and physically assaulted by schoolmates—and by his mother. At the age of nine, his mother hit him until she was exhausted because he would not wear a dress. Génesis says, "She left my spirit broken; I learned to pretend to be a gender that was not mine."

He eventually moved away to Mexico City. There he began his transition. When he decided he would transition, both of Génesis's parents rejected him. The only family member with whom he stays in touch is his grandmother. After he started hormone treatment, he still had a developing chest, so he used bandages to compress it. Then, a friend gave him nylon T-shirts that helped him to compress his chest better "with more freedom of movement."

Génesis is a history student and transactivist. He is finishing his dissertation at Universidad Nacional Autónoma de México. He also works at *Clinica La Condesa*, a center for STD prevention that serves the large LGBTQ community in Mexico City. Génesis is working to establish his own non-governmental organization called Colectivo Hombres XX, dedicated to helping female-to-male transgender people.

Génesis met his partner, a computer engineer and transgender woman, seven years ago. When Génesis underwent a mastectomy in 2010, she took care of him.

"I always had the behavior of a boy, this is the reason I was physically and verbally reprimanded by my mother and some of my schoolmates."

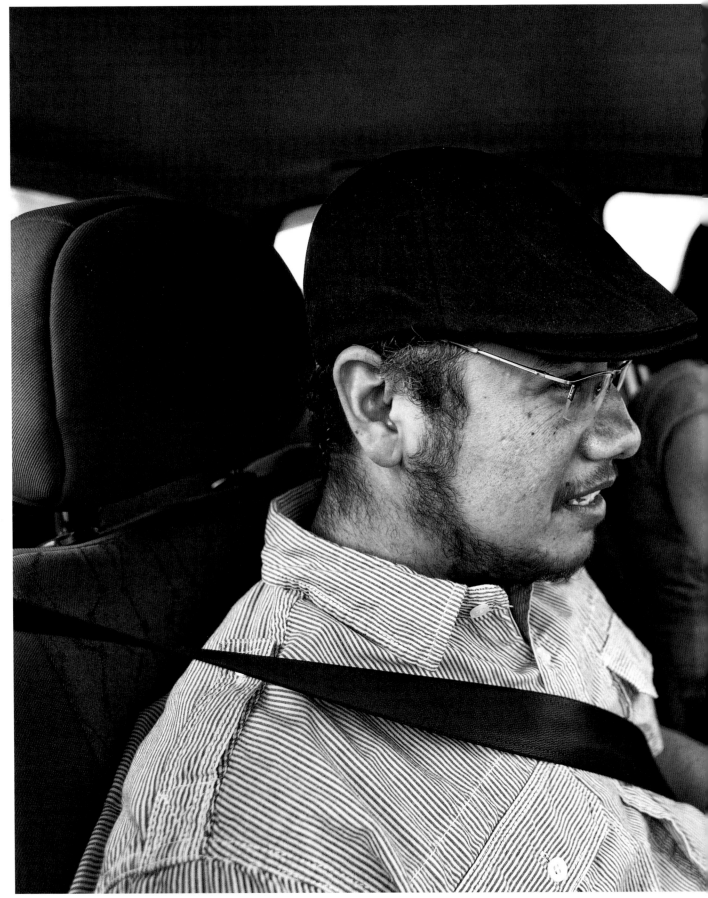

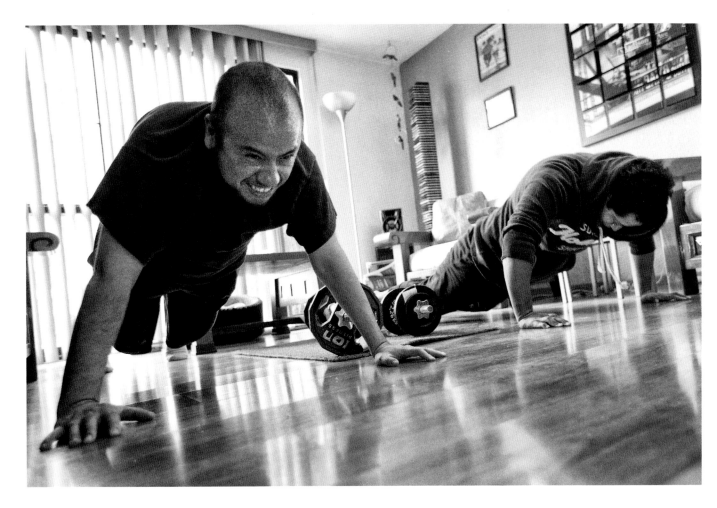

Gabriel, a transgender friend of Génesis, teaches him a workout to develop the musculature of his upper body. Physical training like lifting weights is a fundamental part of gender transition.

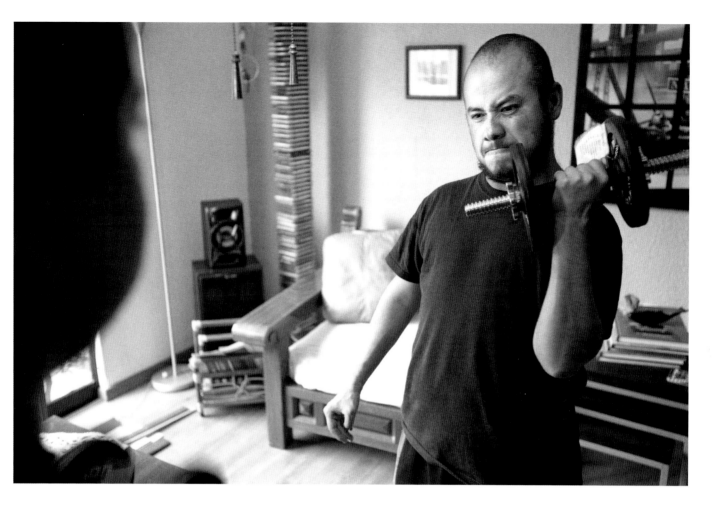

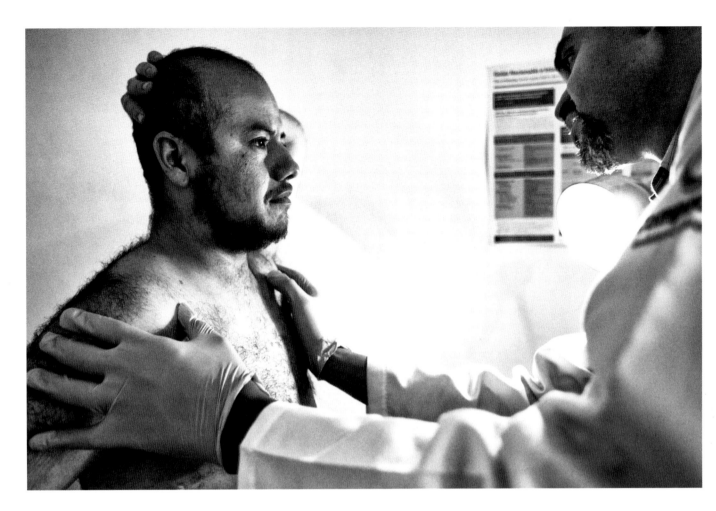

Génesis during one of his regular visits to Dr. Tirso Clemades, physician and director of Cuenta Conmigo, a foundation giving assistance to the LGBT community in Mexico City. While taking male hormones, Génesis needs a checkup every several weeks.

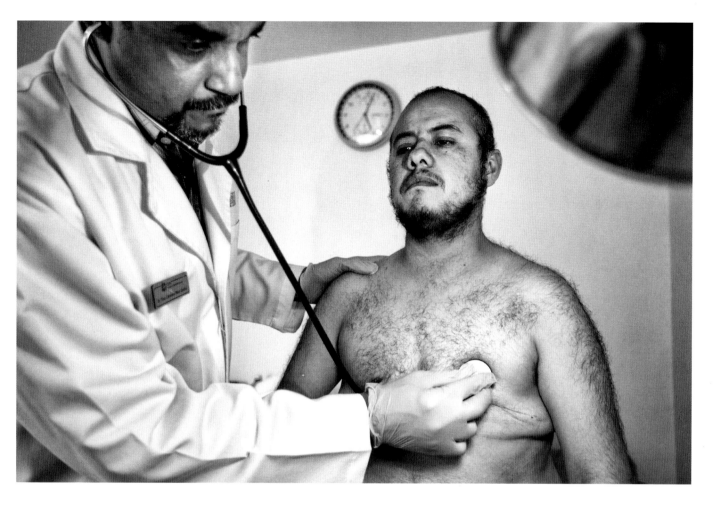

Génesis at *Eje Central*, one of the busiest avenues in downtown Mexico City.

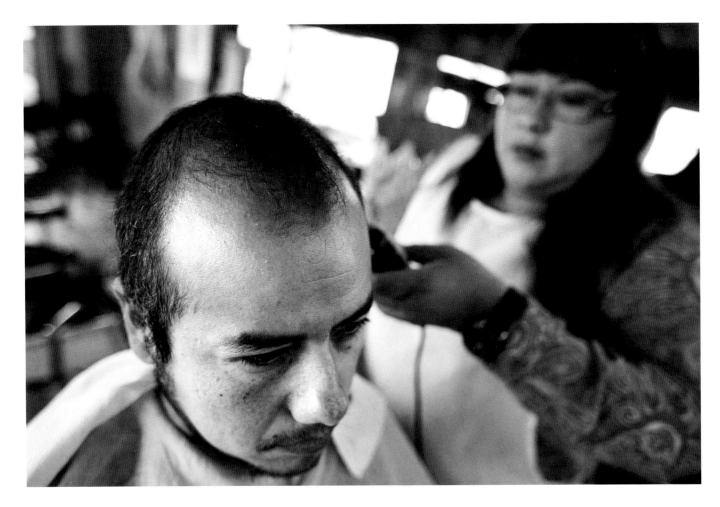

Génesis gets a haircut and shave at a barbershop close to his home in Tenayuca, Mexico City.

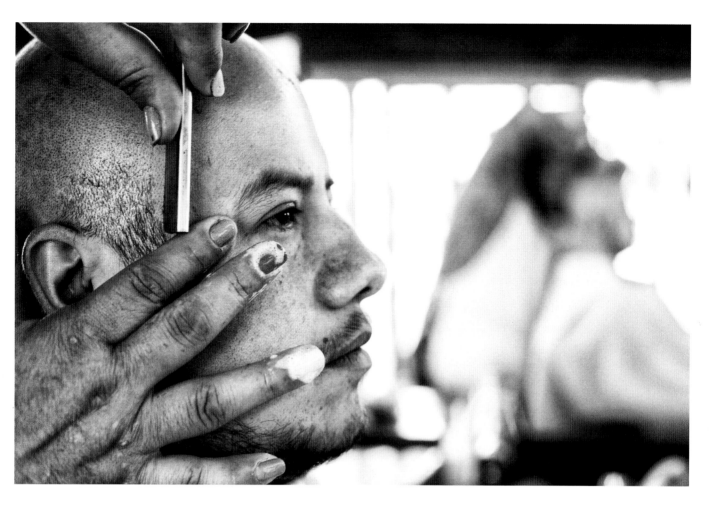

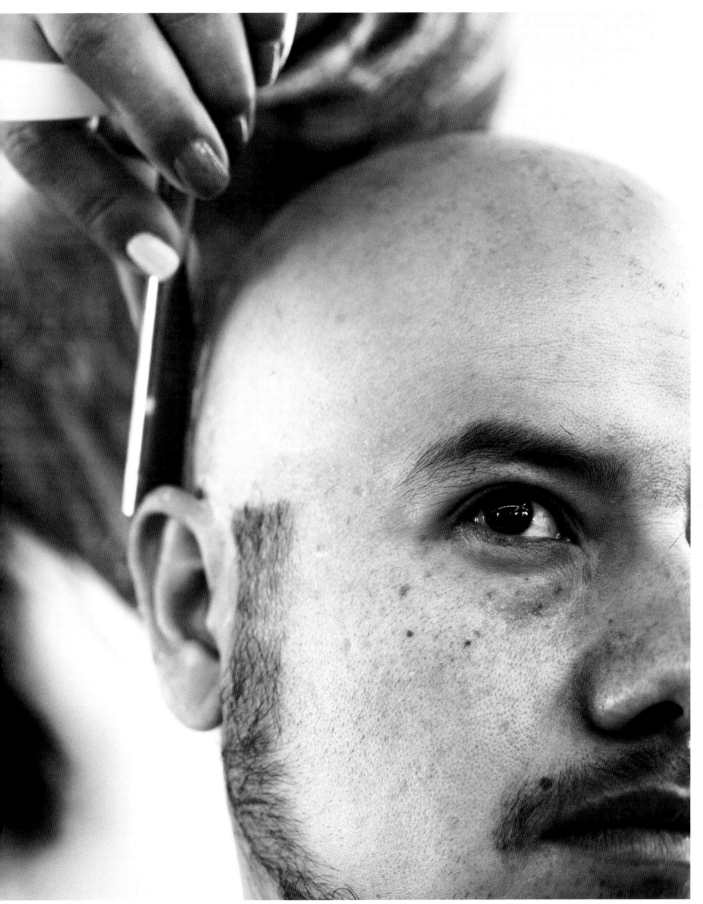

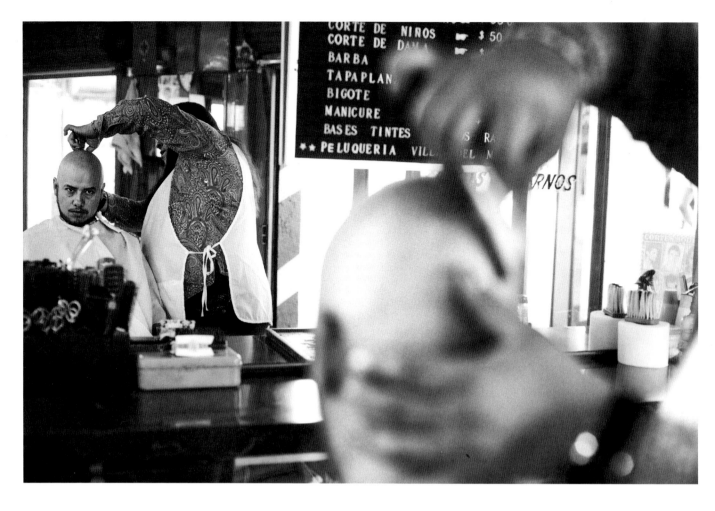

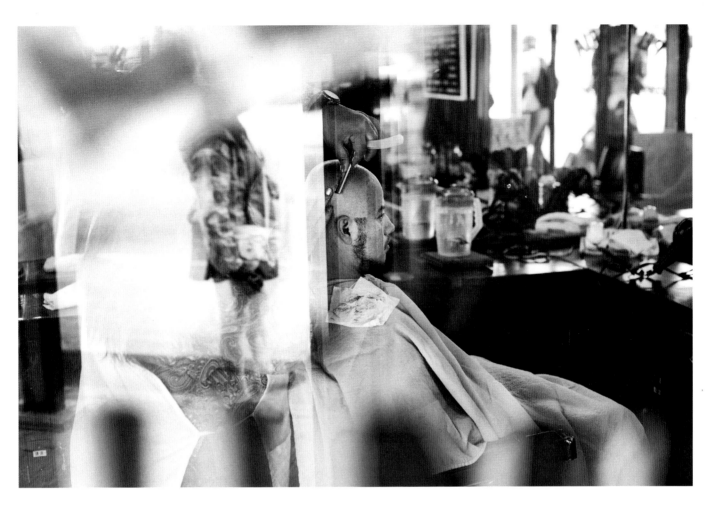

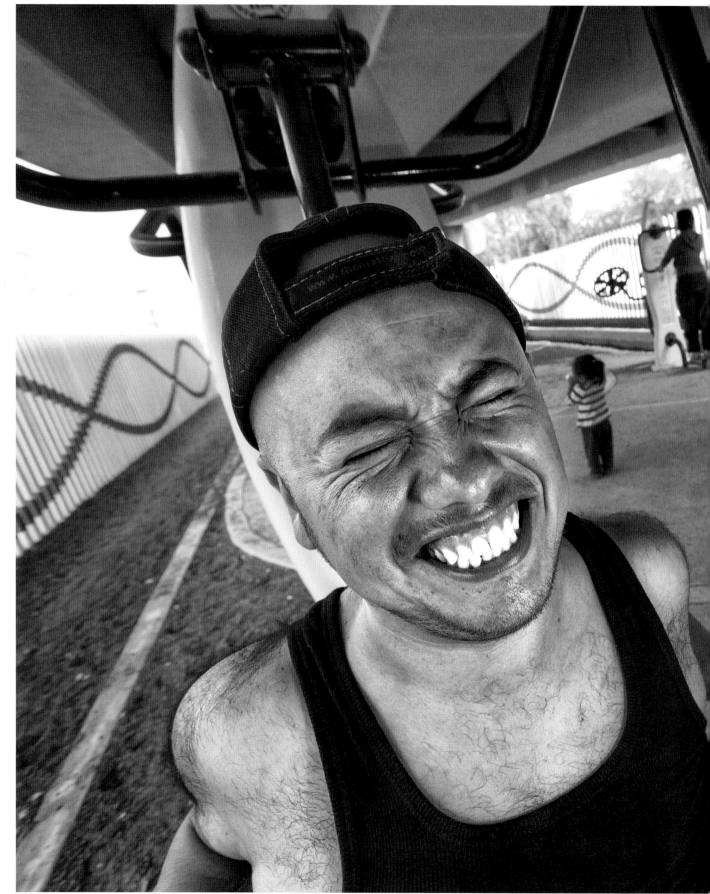

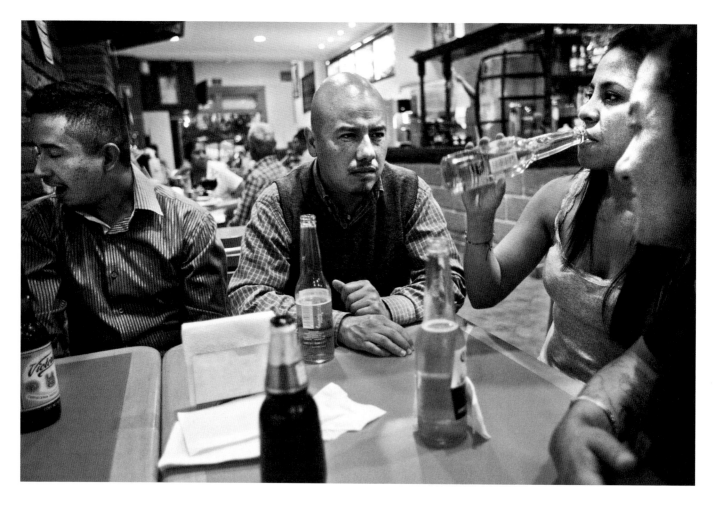

Génesis hangs out with a few transgender friends at a bar in the cosmopolitan Zona Rosa, a favorite neighborhood for the LGBT community of Mexico City.

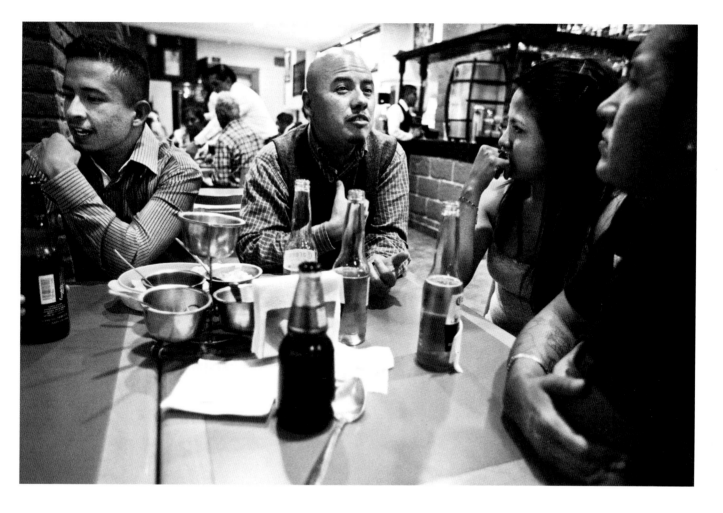

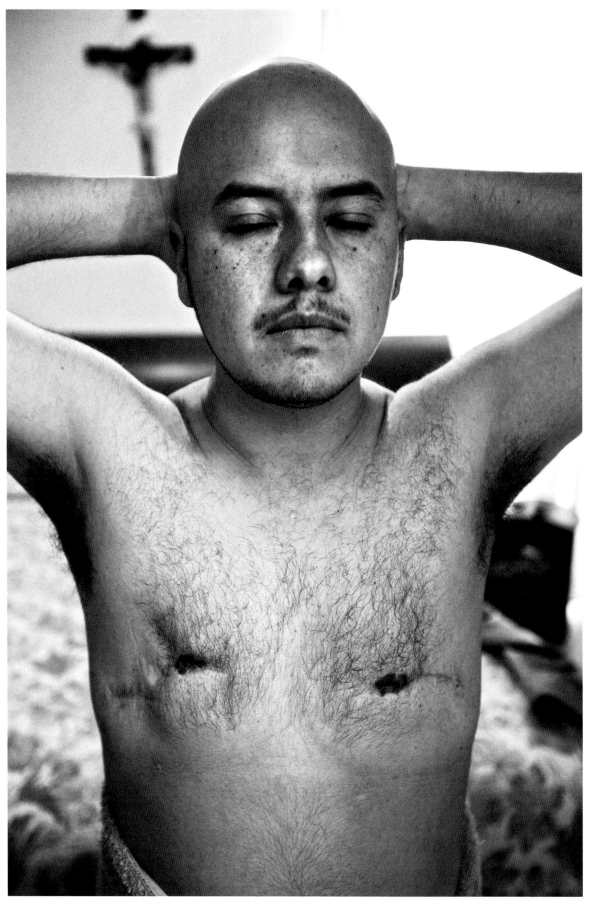

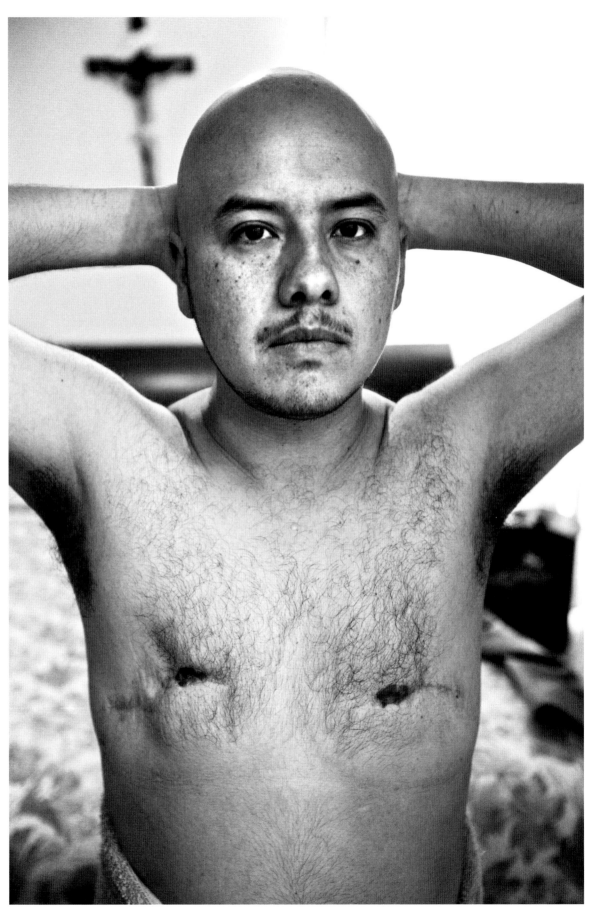

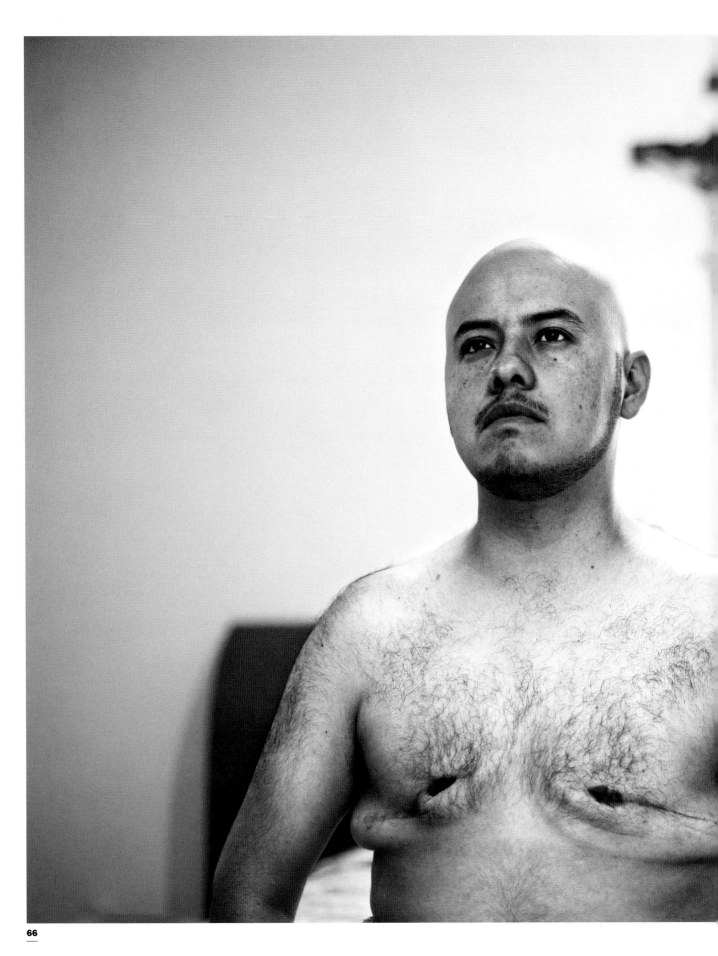

Oyuki Martinez Colin

OYUKI MARTINEZ COLIN IS THIRTY-FOUR YEARS OLD. SHE WAS RAISED IN A POOR FAMILY IN MEXICO CITY.

When Oyuki was eighteen, her father passed away; she assumed responsibility for supporting her family, including several siblings, through sex work on the streets of Ixtapalapa, one of Mexico City's most dangerous neighborhoods. Oyuki says, "It was not the job I was looking for."

From a young age, Oyuki was a victim of violence for not fitting the established norms. In 2012, Oyuki graduated from Universidad Nacional Autónoma de México with a bachelor's degree in political science. Due to her transgender identity, she has not been able to find a job. Oyuki continues to earn a living as a sex worker and a transactivist, working in HIV/AIDS-prevention within the high-risk transgender community and among Ixtapalapa's sex workers. Oyuki is determined to quit sex work and find a job based on her college education and social activism.

In 2002, Oyuki adopted a two-month-old abandoned girl, Sorey Sarai. Oyuki says, "Today I have a family and I am very grateful for my beloved daughter Sorey, the light of my life."

"I recall being a victim of violence as far back as I can remember, at around six or eight years old, for not fitting the established norms."

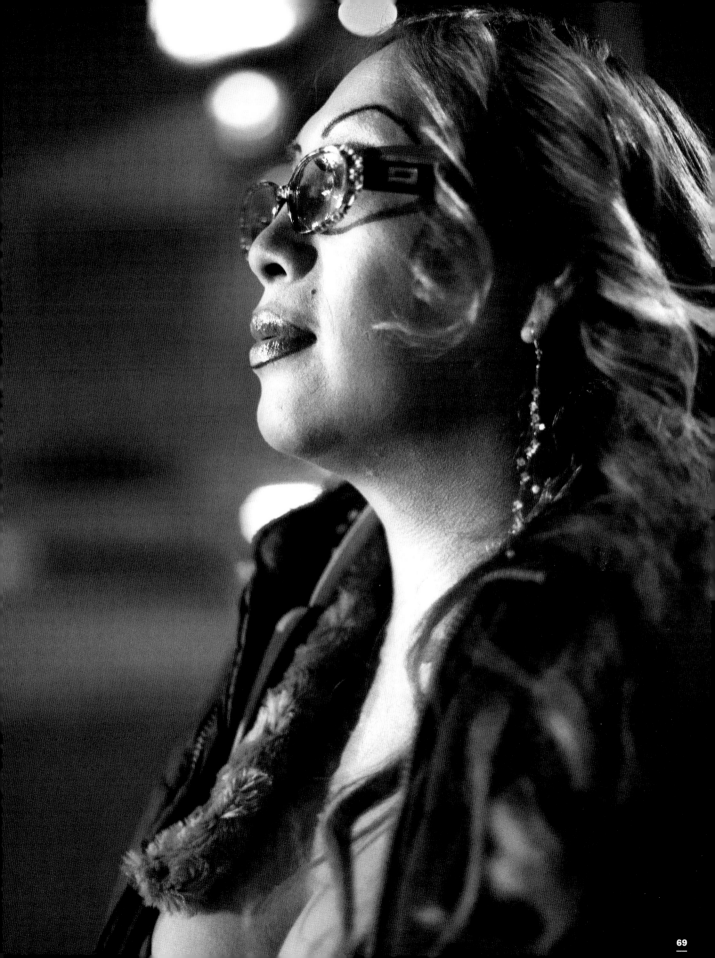

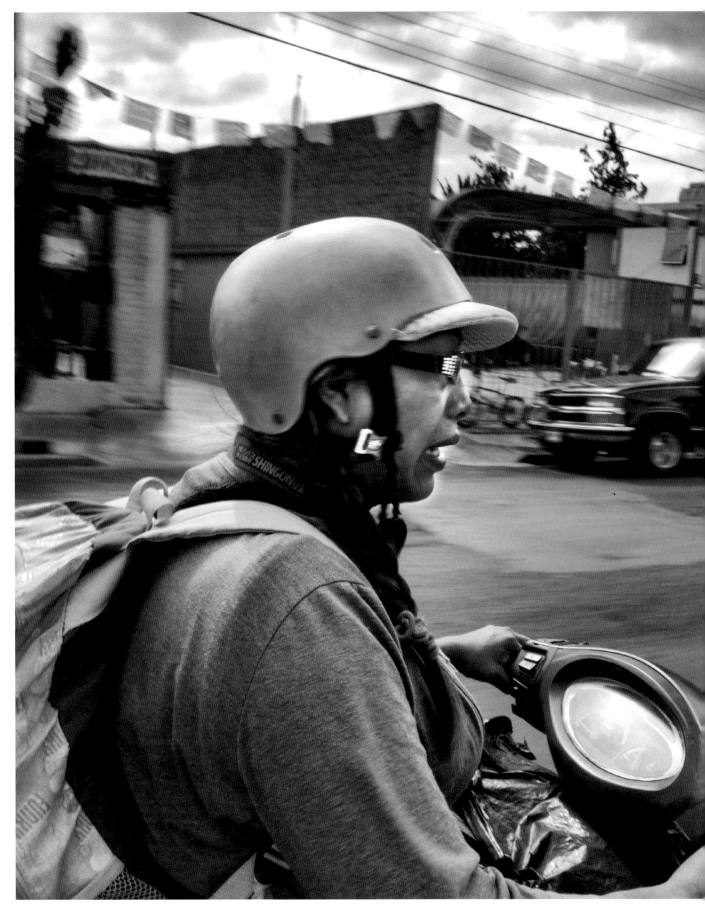

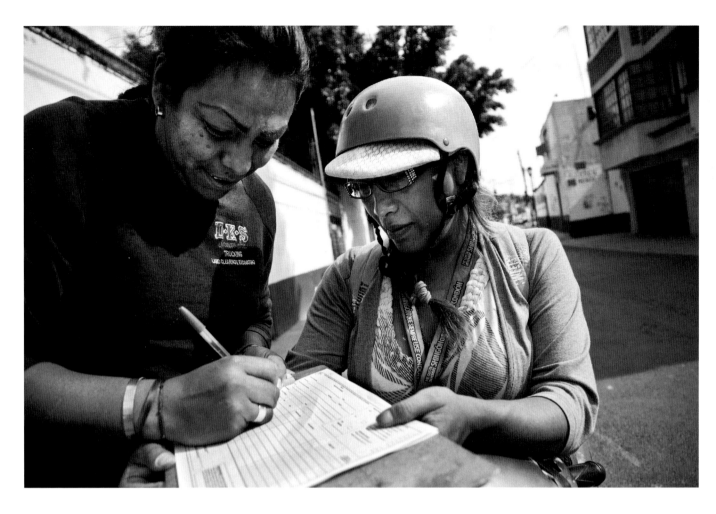

During the daytime, Oyuki works for *Centro de Apoyo a las Comunidades Trans* (Center for Support of the Trans Community), an organization affiliated with the Global Fund to Fight AIDS, Tuberculosis, and Malaria.

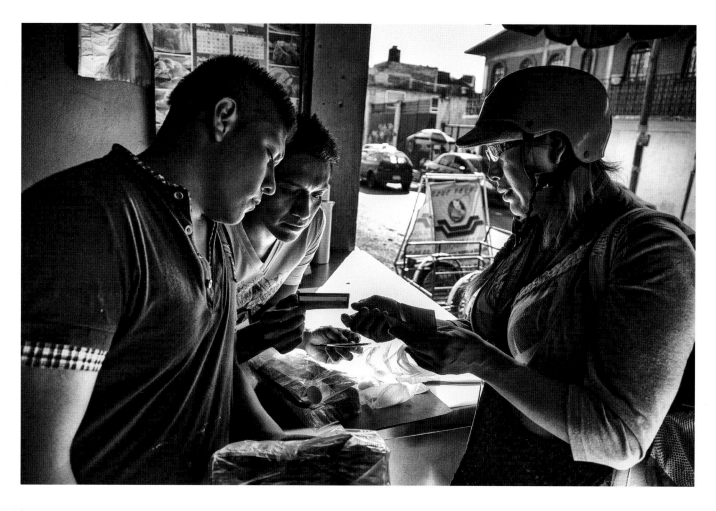

Part of Oyuki's job is to reach out to transgender sexual workers about how to distribute condoms as well as literature about how to prevent HIV infection as well as other diseases. Then, at night, she works as a prostitute.

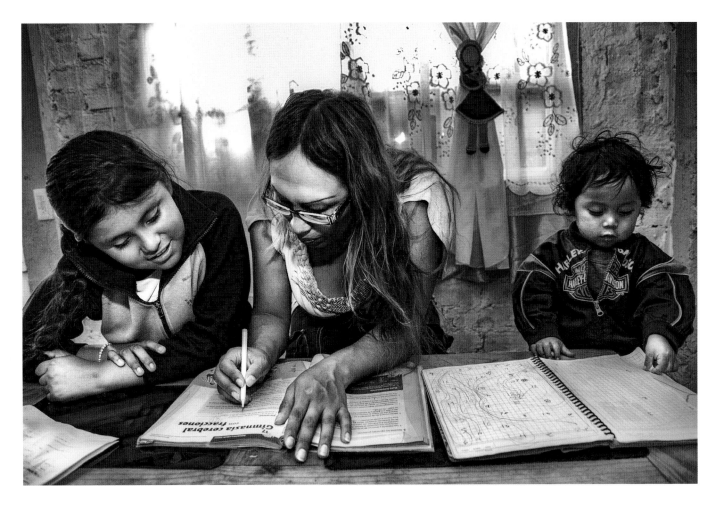

Oyuki works hard to make sure Sorey will succeed in the future. She drops Sorey off at school every morning and picks her up each afternoon; she also helps her with homework and participates in parent activities at the school.

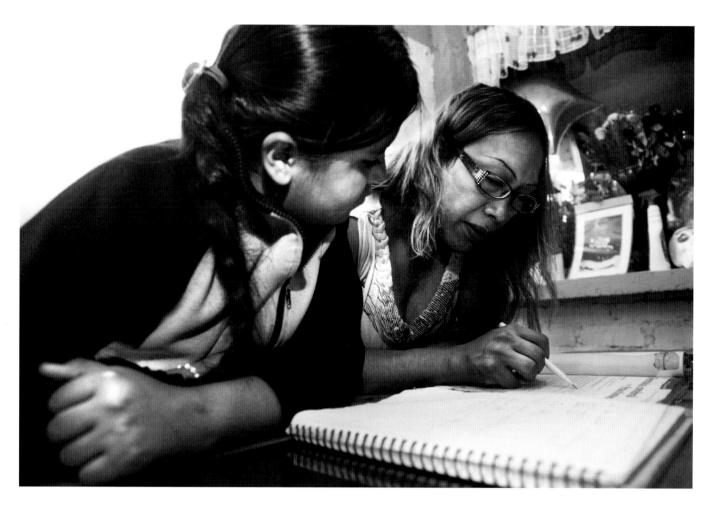

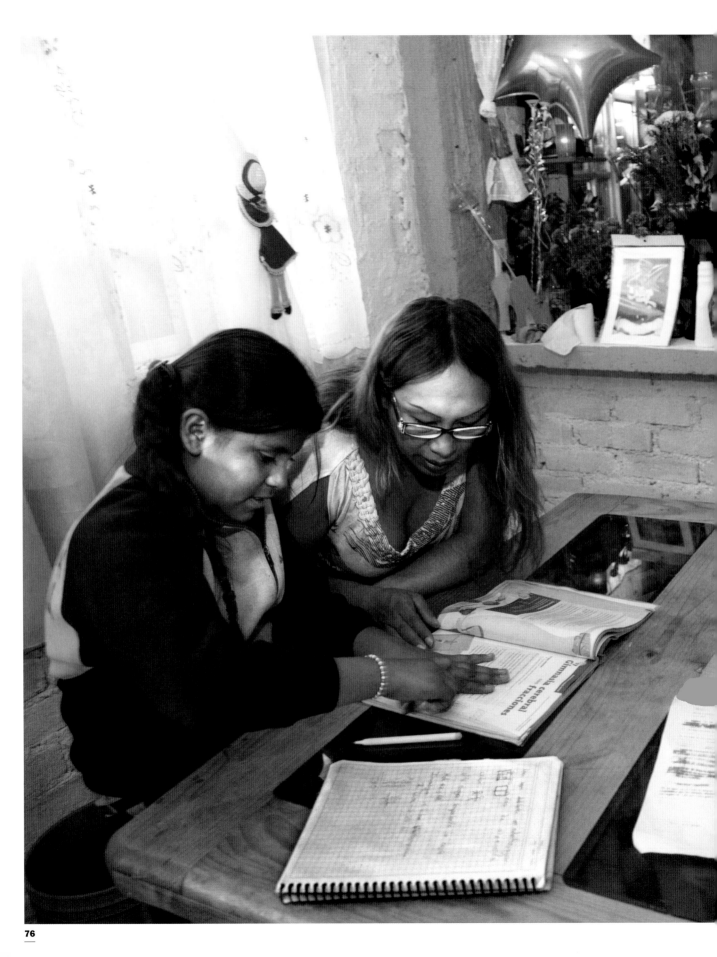

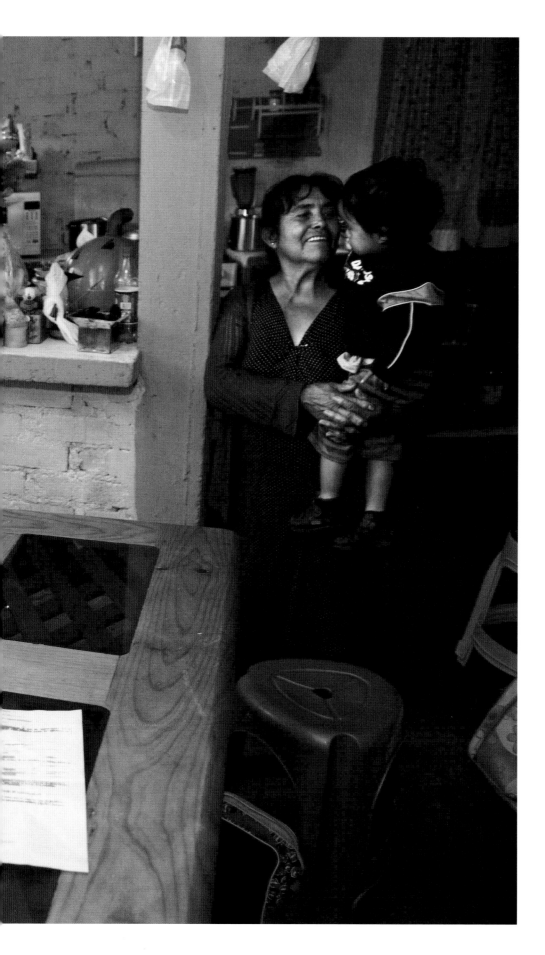

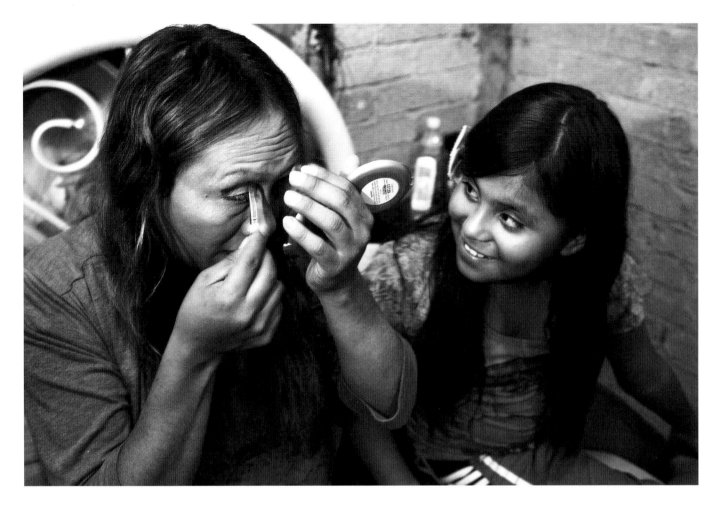

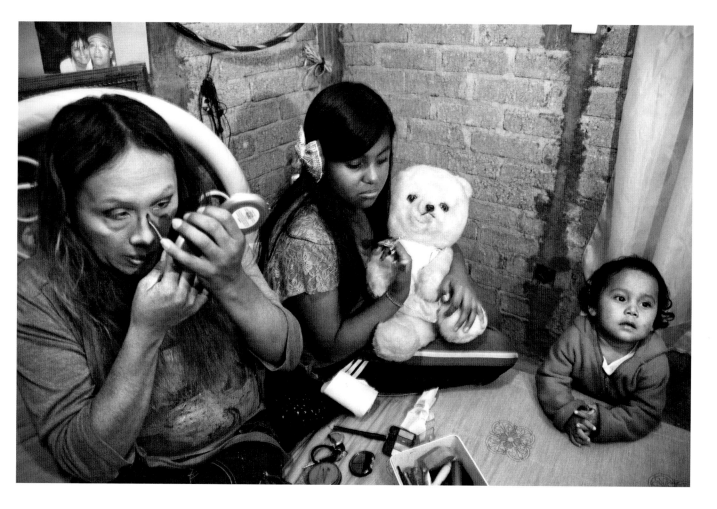

Oyuki prepares to work while her adopted daughter Sorey and her nephew Donovan watch. Careful makeup, stylish hair, and sexy clothes are essential when it comes to walking the streets of Mexico City in search of clients.

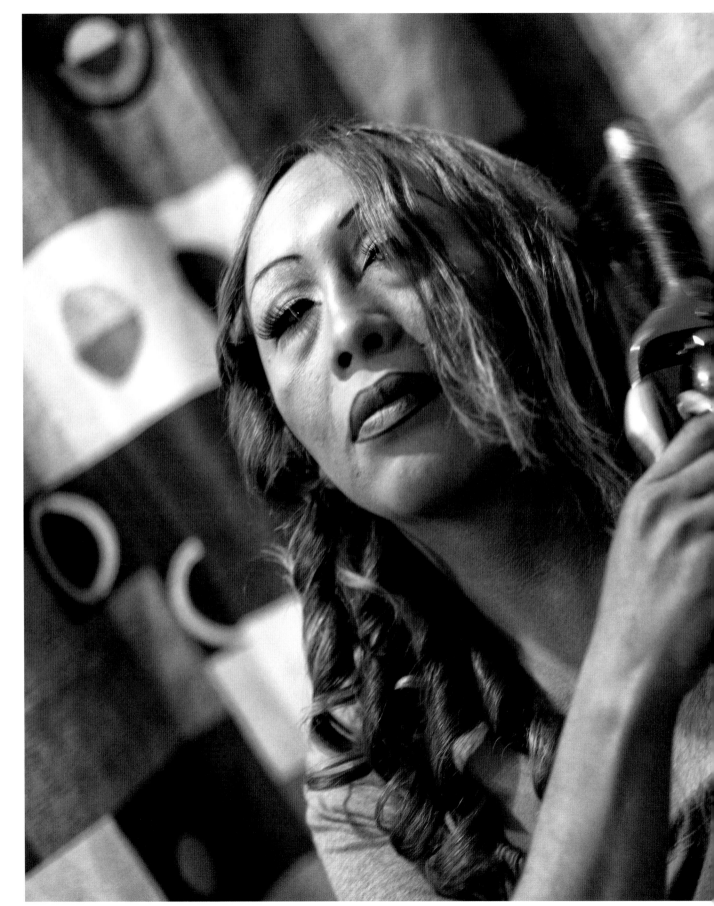

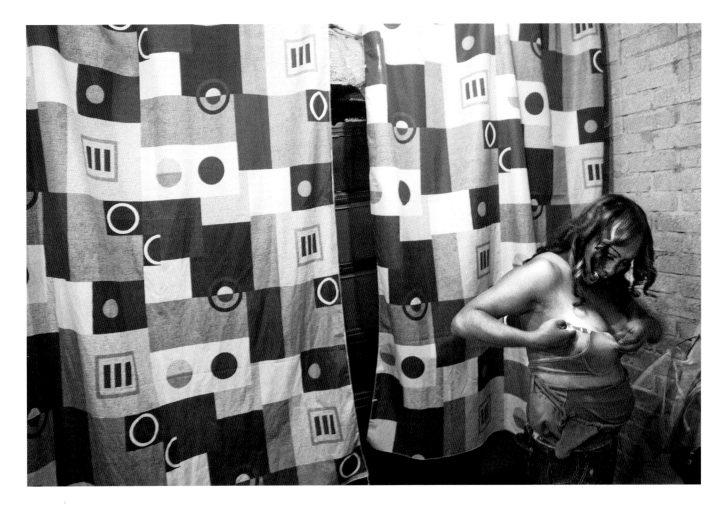

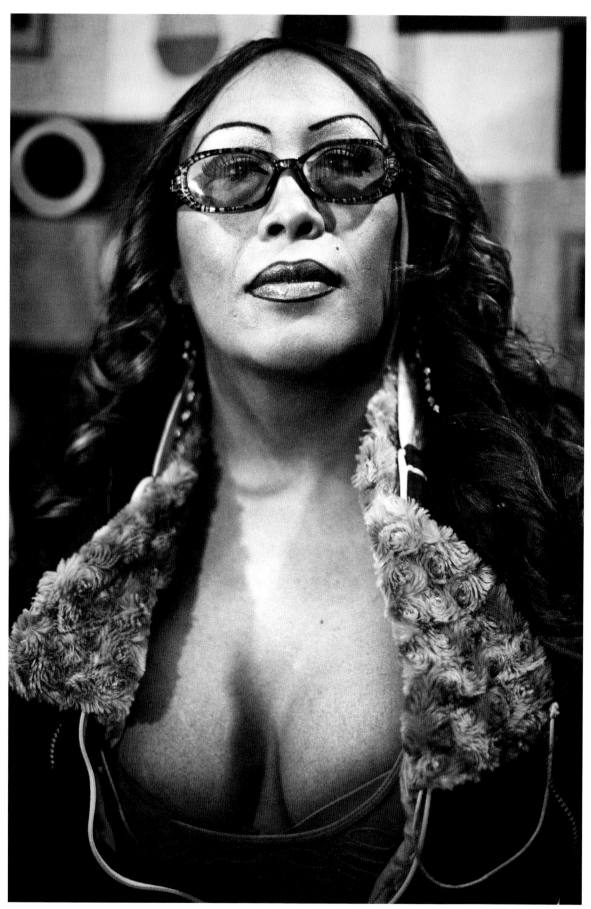

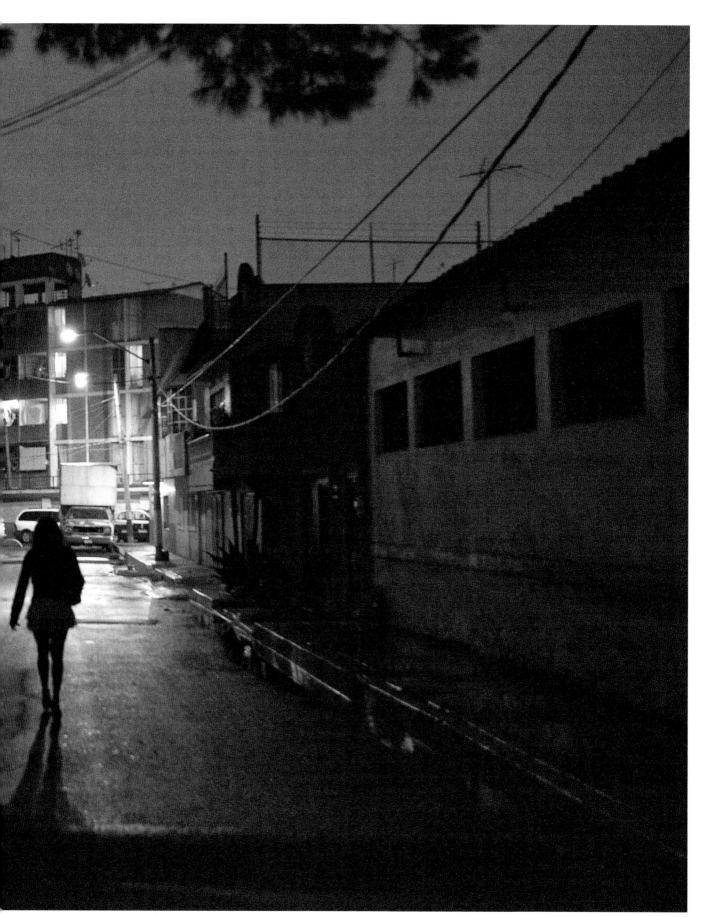

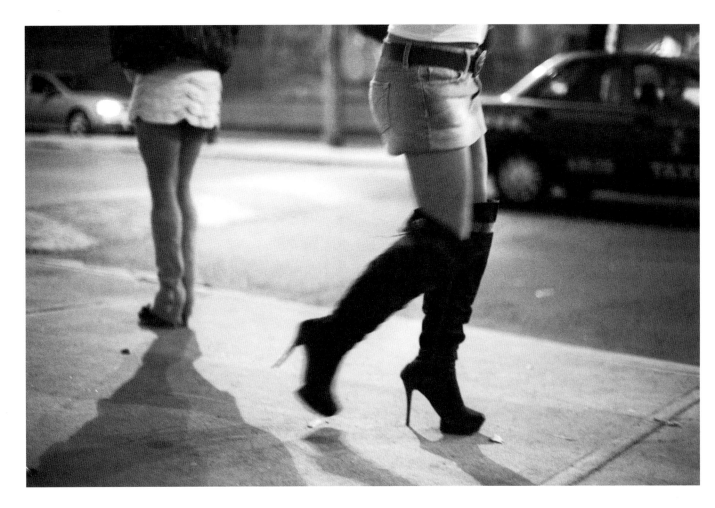

Oyuki (left) walks the dangerous streets of Ixtapalapa late at night.

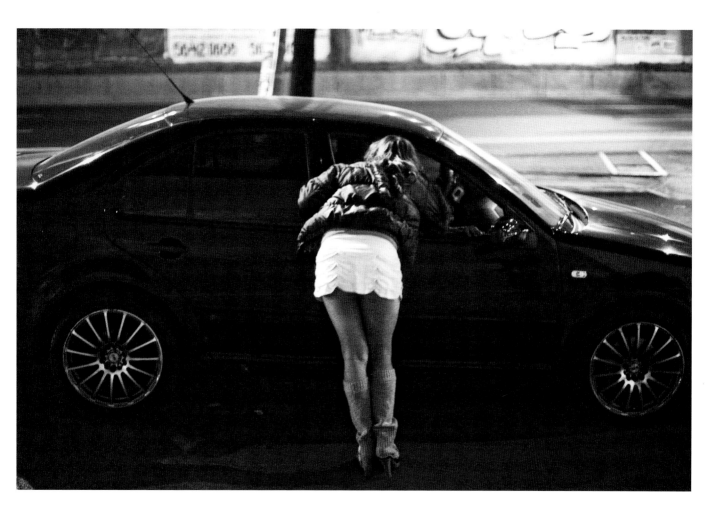

Oyuki meets a potential client on the streets of Ixtapalapa, a deprived area of Mexico City.

As a car with a potential client stops, Oyuki approaches to negotiate the service and fee.

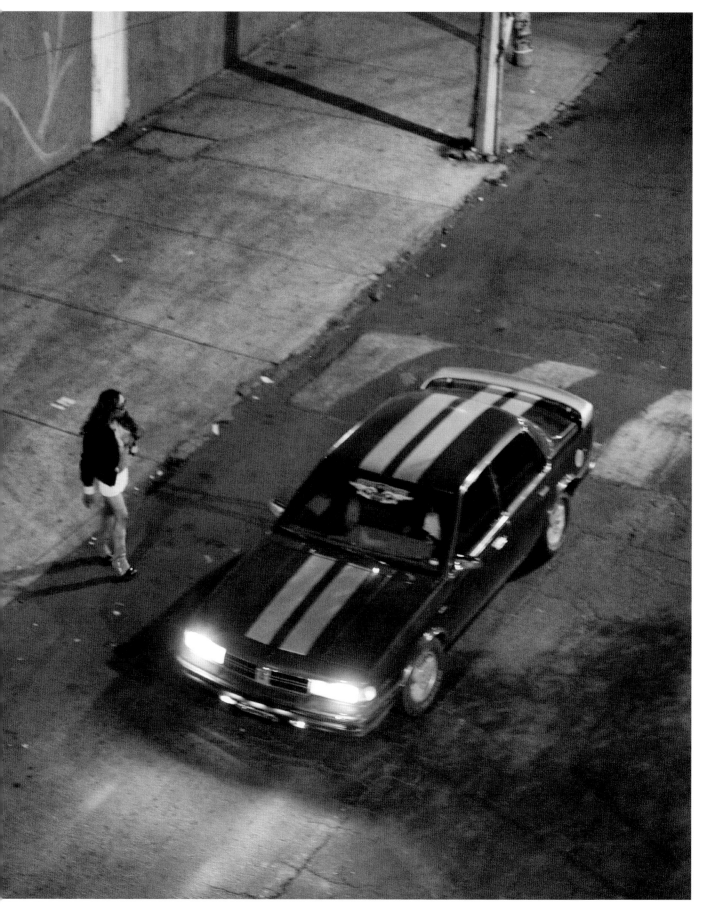

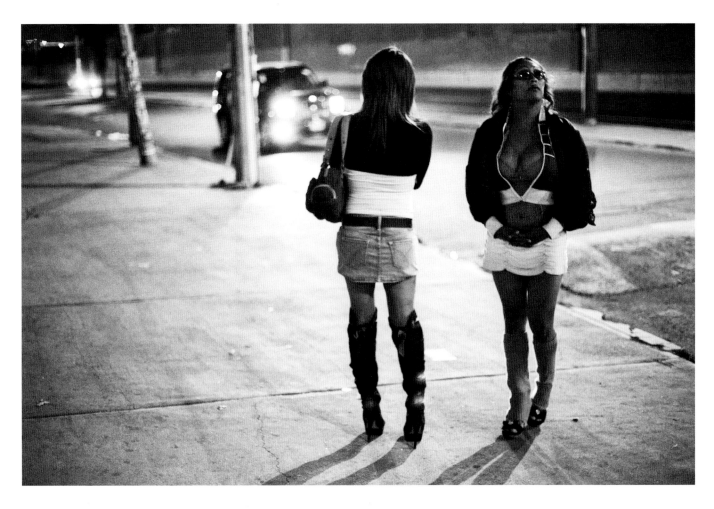

Late at night, Oyuki and a friend wait for customers on a lonely street of Ixtapalapa.

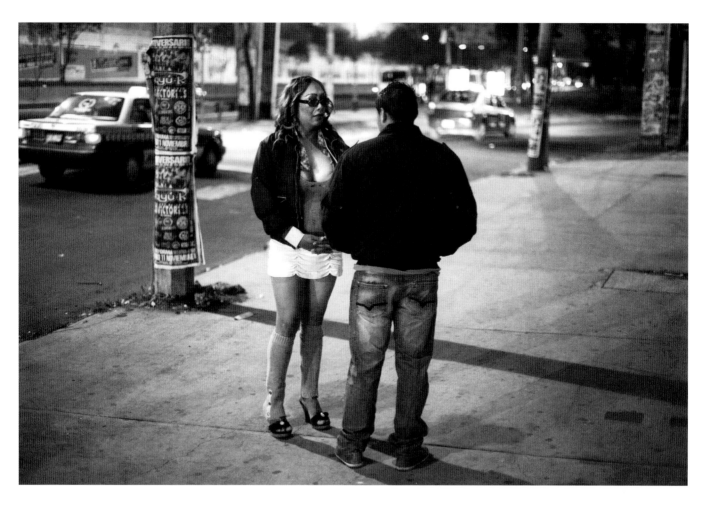

Oyuki negotiates her fee with a potential customer.

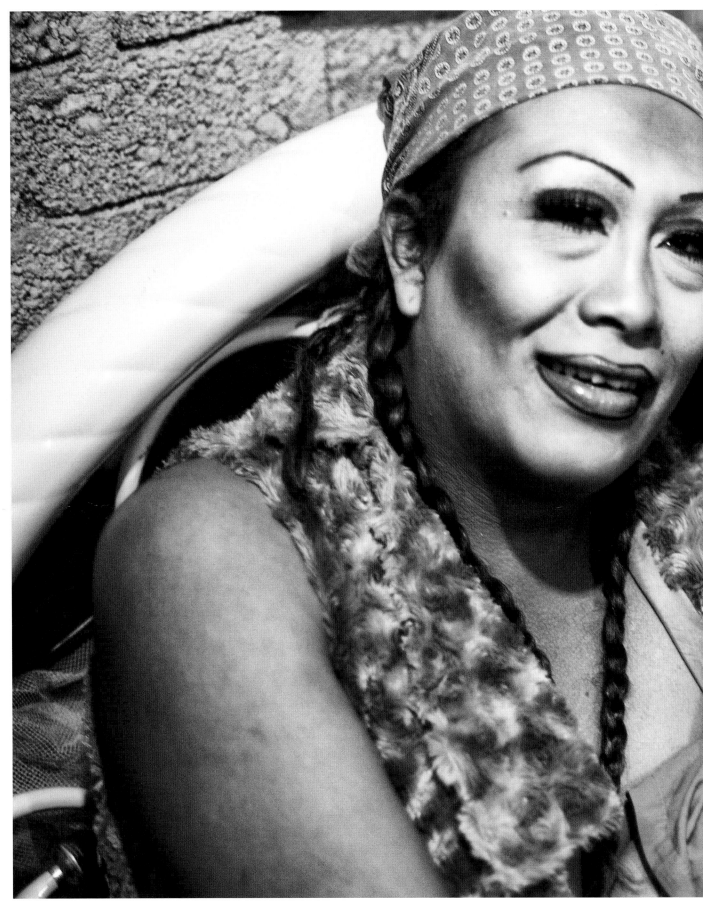

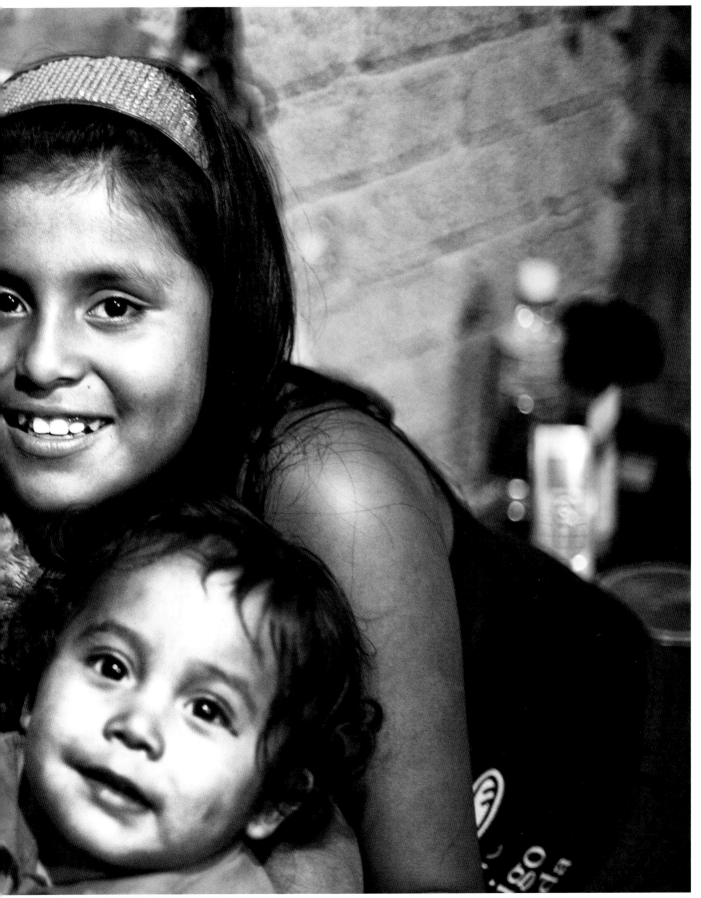

Mario Sanchez Perez & Diana Laura Guerrero Sandoval

MARIO AND DIANA GAINED NATIONAL ATTENTION IN 2008. ON MAY 17, THE INTERNATIONAL DAY AGAINST HOMOPHOBIA, THEY BECAME THE FIRST TRANSGENDER COUPLE TO MARRY IN MEXICO.

Mario is a sixty-year-old transgender man who comes from El Real de Mina, a small town about an hour and a half away from Mexico City. His father couldn't afford to send him or his ten siblings to primary school. Mario eventually made his way to college, although he was forced to drop out in order to work.

From the age of two, Mario knew that he wanted to live and be recognized as a man. As an adolescent, he was attracted to women, but growing up in small town in the 1950s, he knew little about what it meant to be lesbian. At twenty-two, Mario had his first relationship with a woman. It was a revelation. "I didn't know that [two] women could love, kiss, and have sex!" he said.

Diana is a fifty-year-old transgender woman. Growing up in Mexico City, where she graduated from college, she felt no attraction to the opposite sex. For many years, Diana felt she had no place in society. She suffered depression and even considered suicide. Diana could not identify the cause of her unhappiness until one day she heard about the transgender community on the radio and thought that transitioning could be her path.

Diana met Mario in 1999. A year earlier, Diana had decided to transition to female. She quit her job at a communications company and immediately began hormone replacement treatment. In 2007, she underwent sex reassignment surgery, and Mario helped her to recuperate after the operation. In the meantime, Mario, at the age of forty-nine, had his breasts removed. He could have done this earlier, but information on the procedure was scarce in Mexico.

Today Diana lives in Mexico City and works as an advisor and educator in crime prevention for the city council. Mario retired from his job in Mexico's penitentiary system and splits his time between Mexico City and his home in El Real de Mina. Both are committed transactivists and have been invited to speak at conferences around the world. Their foundation, *Grupo Gen-T*, helps transgender people to change their name and gender in public records—usually a long and complicated bureaucratic process.

"Sexually, we get along very well, we are a man and a woman anywhere. We have all the skin to love each other."—MARIO

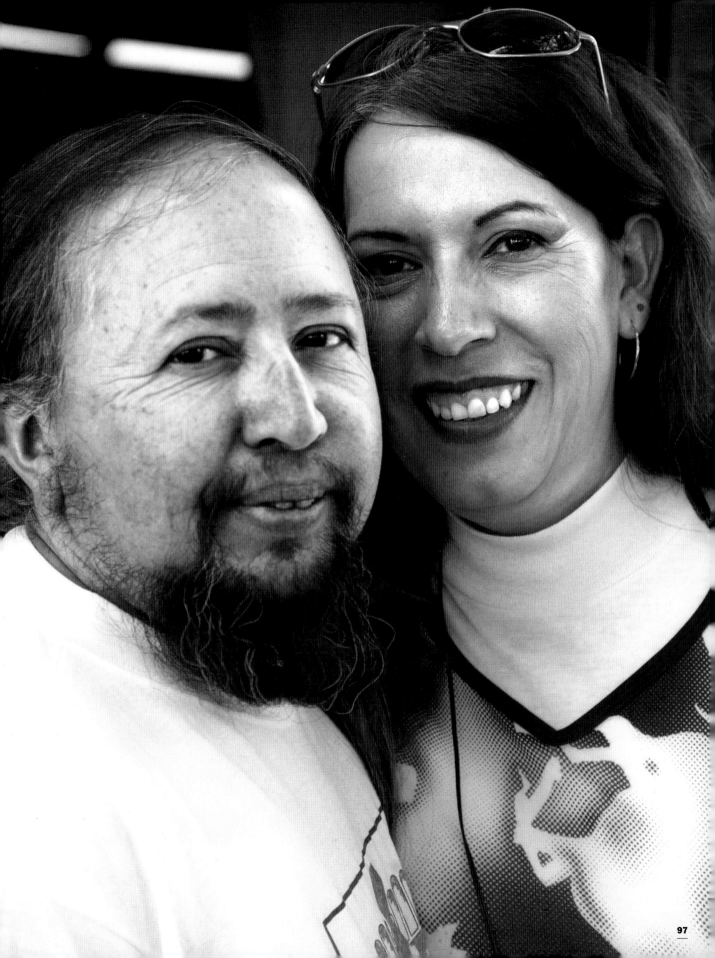

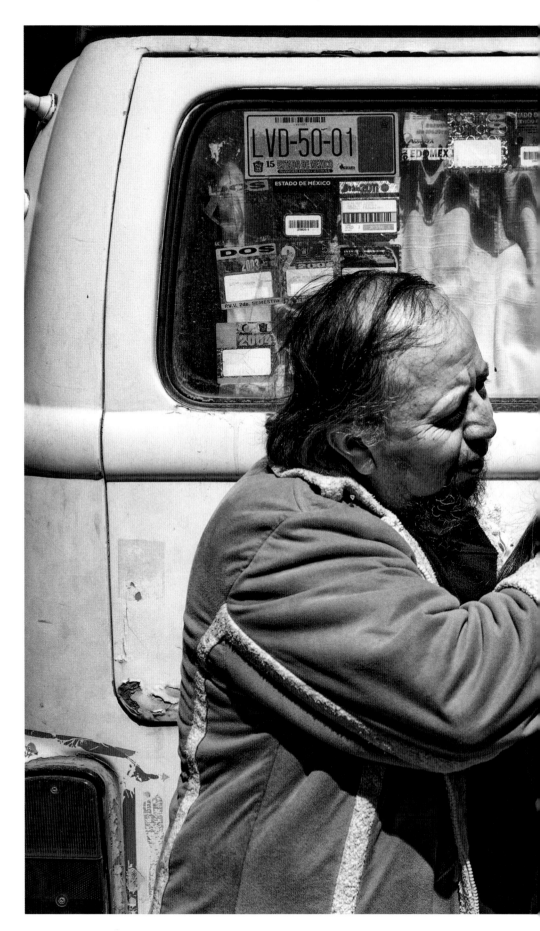

Diana and Mario photographed in the driveway of their house in El Real de Mina in the state of Hidalgo.

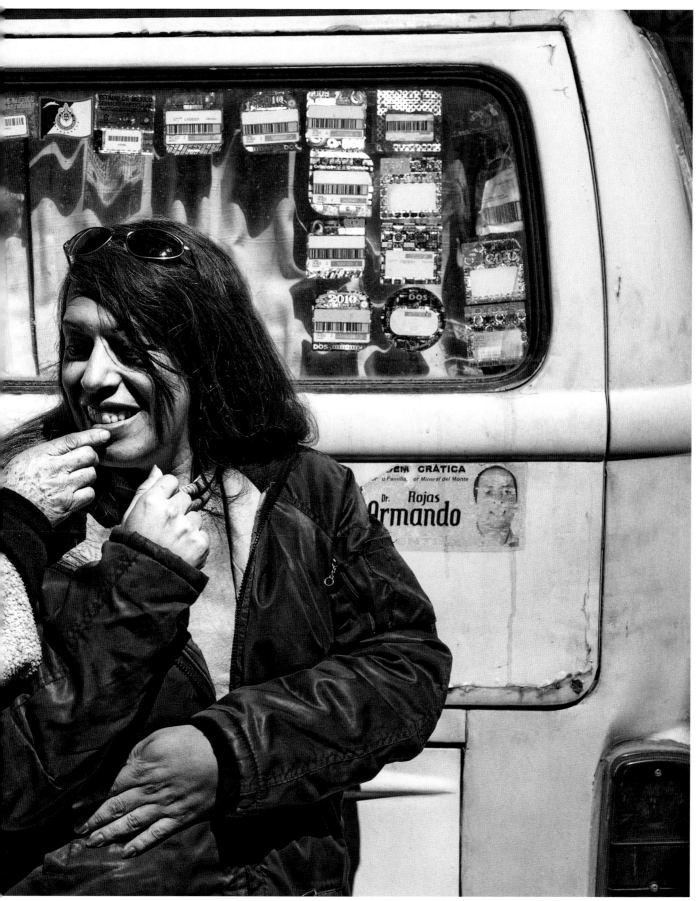

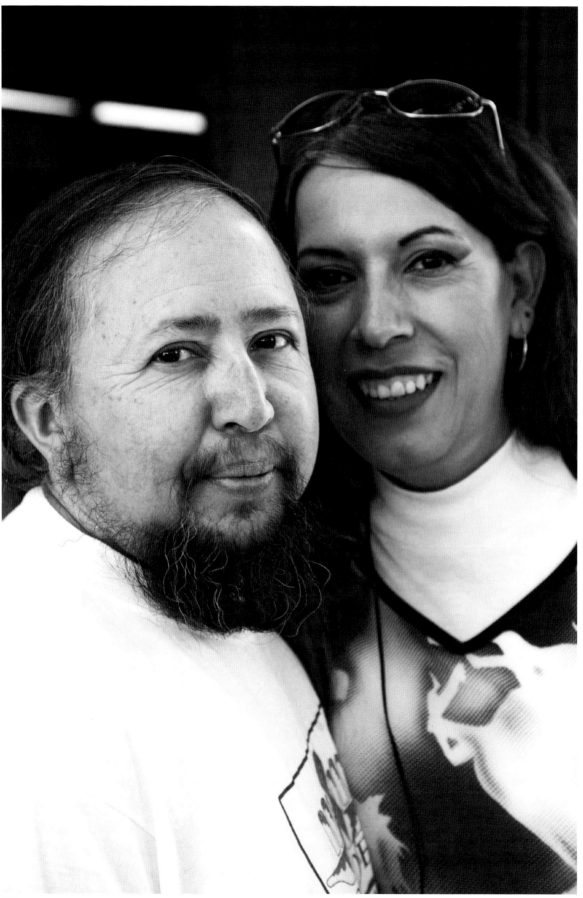

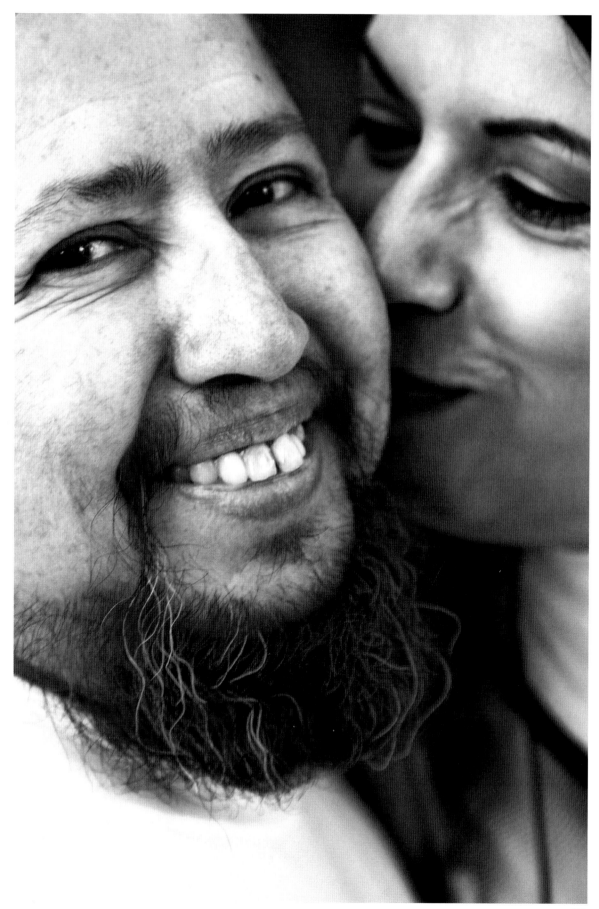

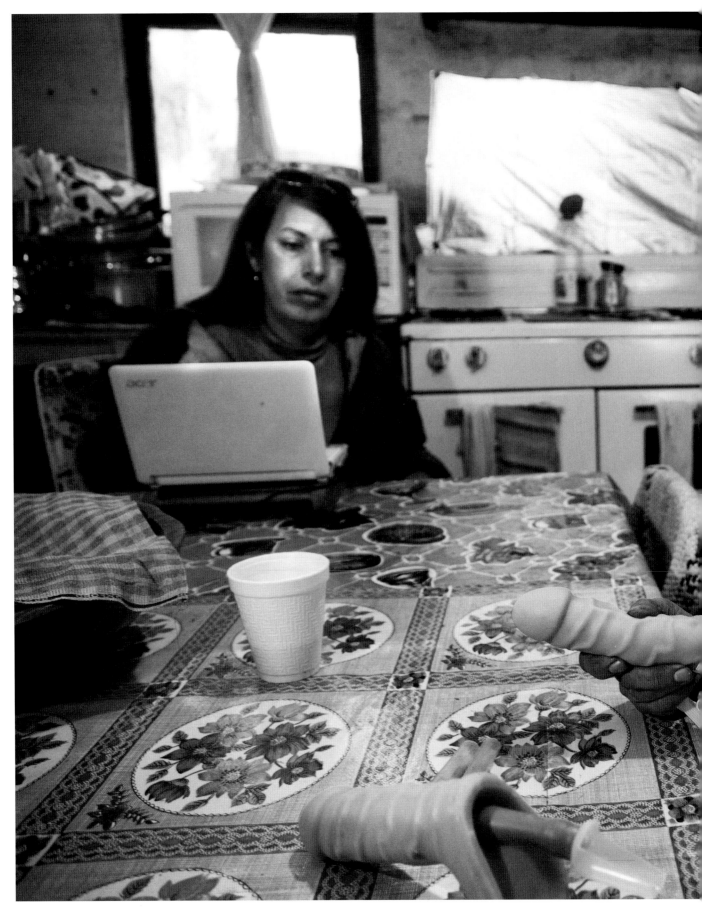

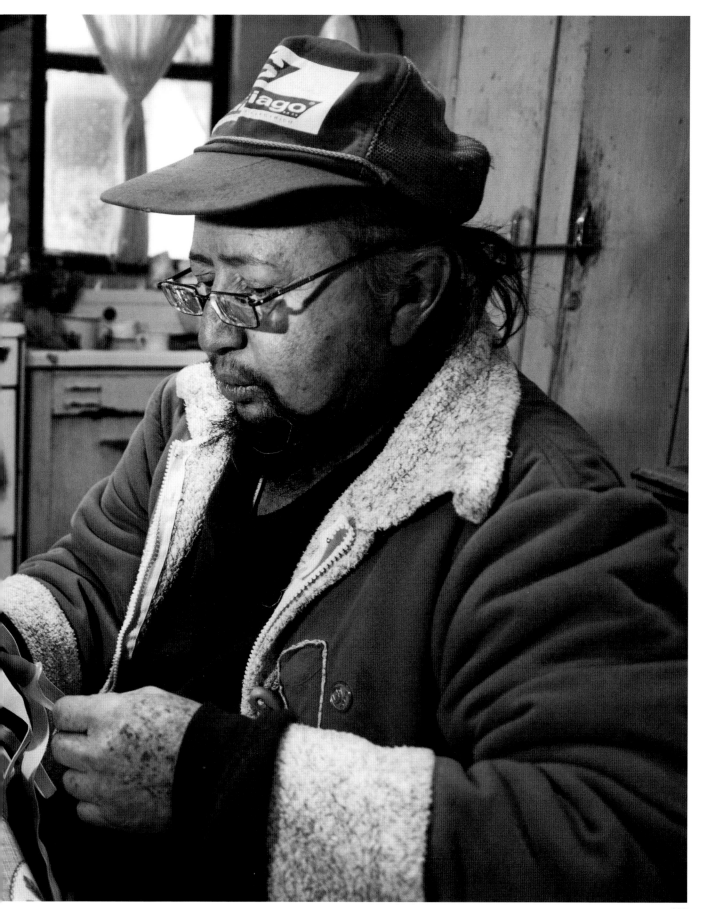

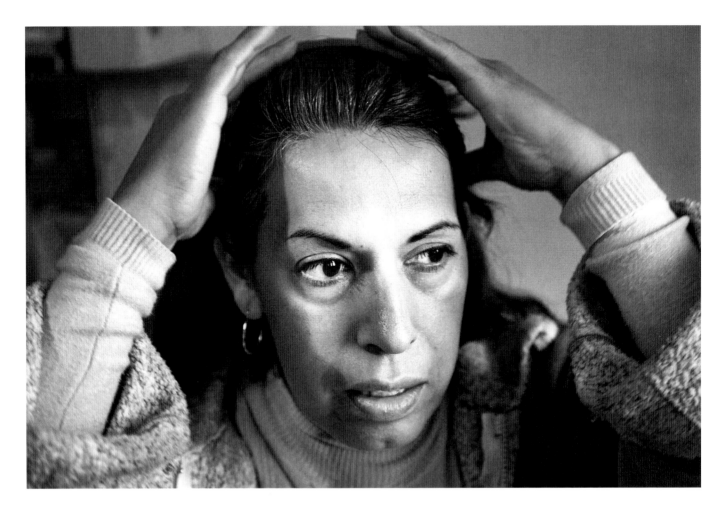

Diana doing her makeup and fixing her hair before going out.

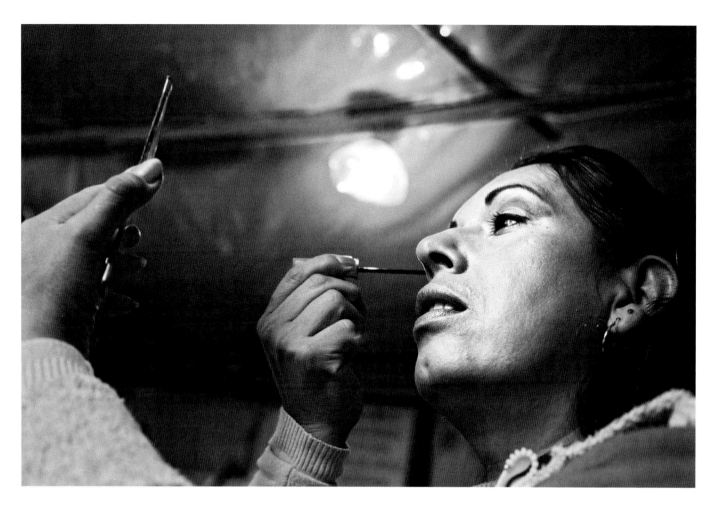

Diana commutes by public transportation to her home in Mipalta, one of the last neighborhoods in the south of Mexico City. It takes Diana about two hours to commute in the morning to downtown Mexico City where she works and two hours back to her house. The last 300 meters is a walk through an agricultural lot.

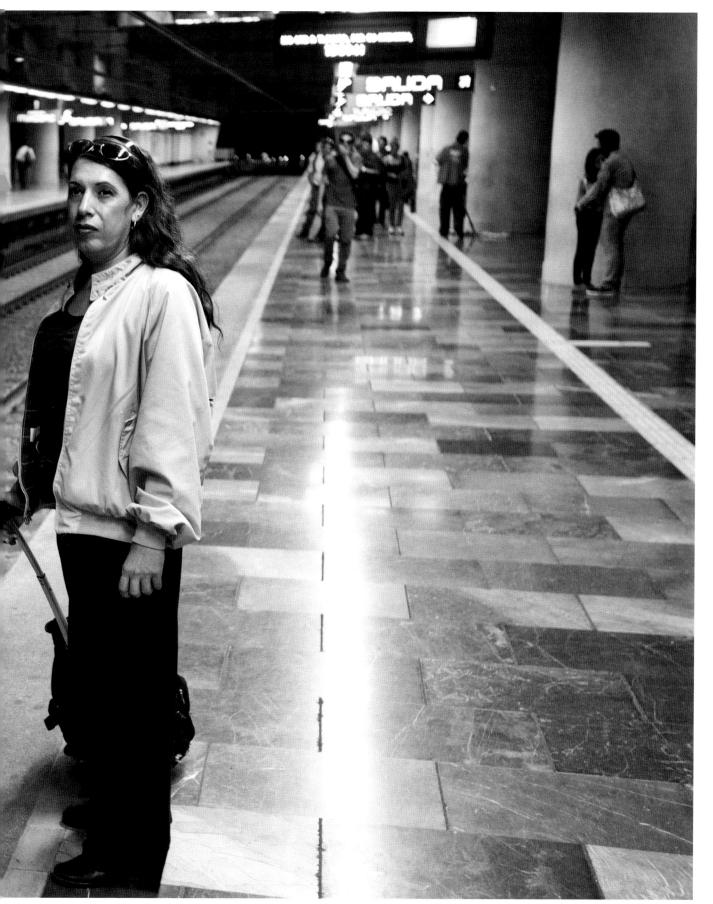

Diana and Mario participate as actors in the play *Yo Fui Una de los 41* (I Was One of the 41). Based on historical facts, the play is about a police raid of a trans party in the early 1900s. The party was organized by young members of the upper class in Mexico City. Forty-one transgender people were detained by the police in the raid. All were later released except for one working-class man, who was imprisoned for many years in a remote jail. Mirna Pulido, a transgender lawyer and close friend of Mario and Diana, wrote the play.

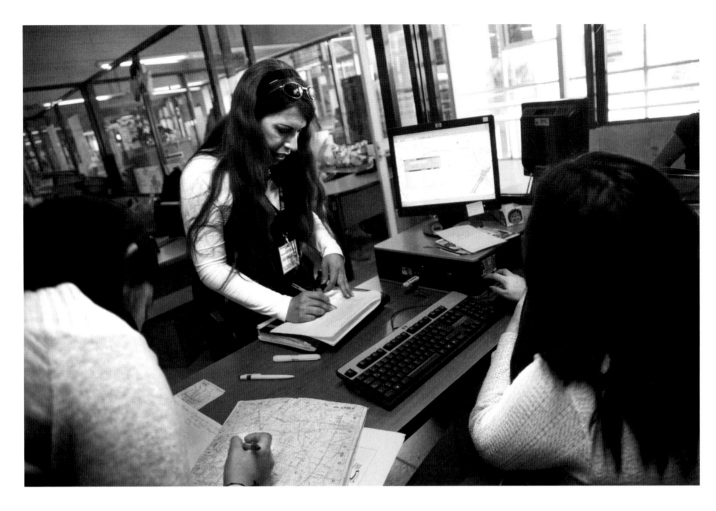

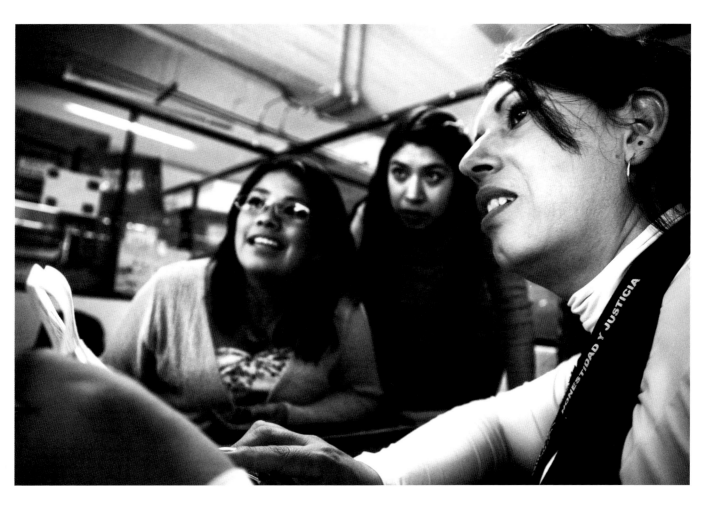

Diana teaches a class on crime prevention at a school in the outskirts of Mexico City. She graduated with an engineering degree from UNAM (Universidad Autónoma de Mexico). She left her job of many years with a communications company and began the transition process. Today, Diana works for the city government as a crime prevention lecturer.

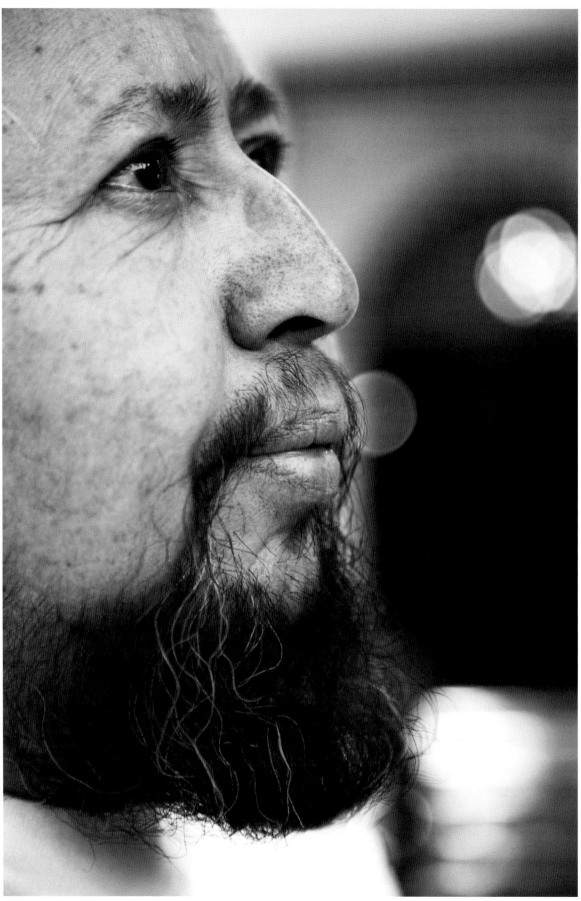

(Opposite page) A portrait of Mario at a young age when he was named Maria Del Socorro. Photo courtesy of Mario.

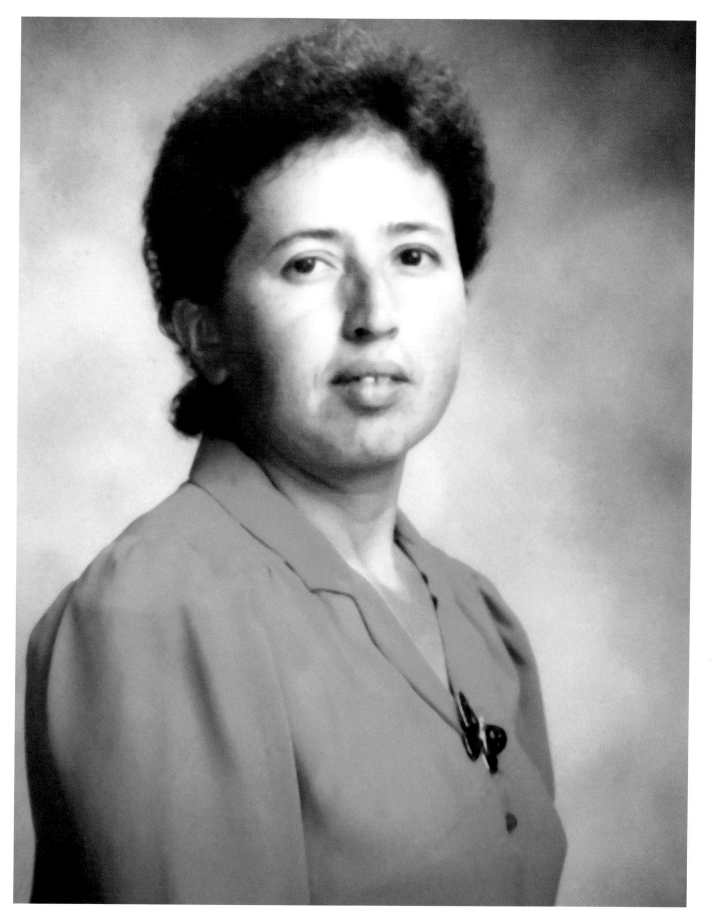

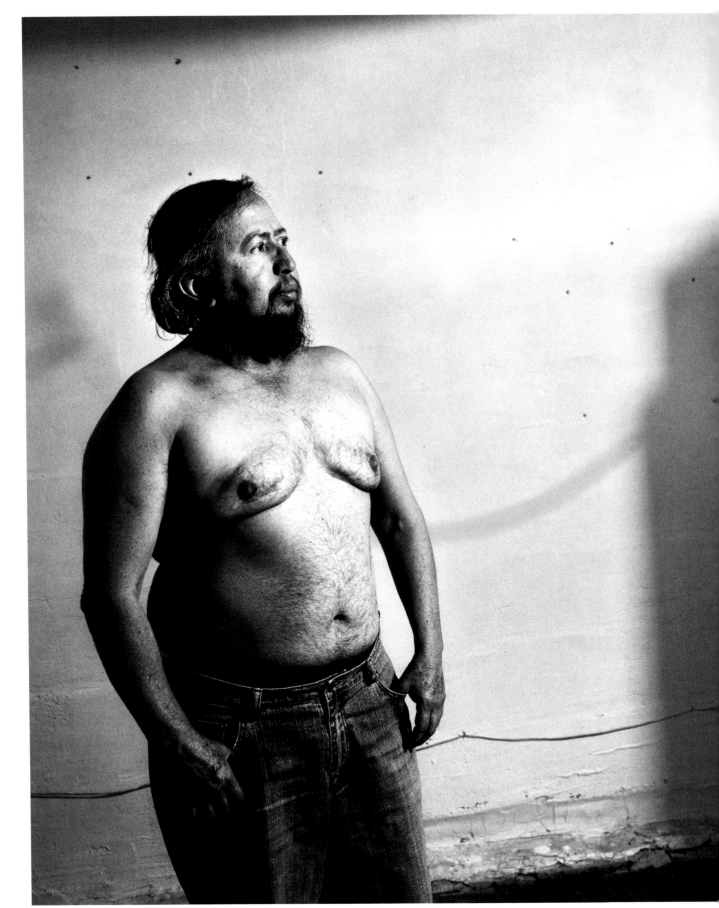

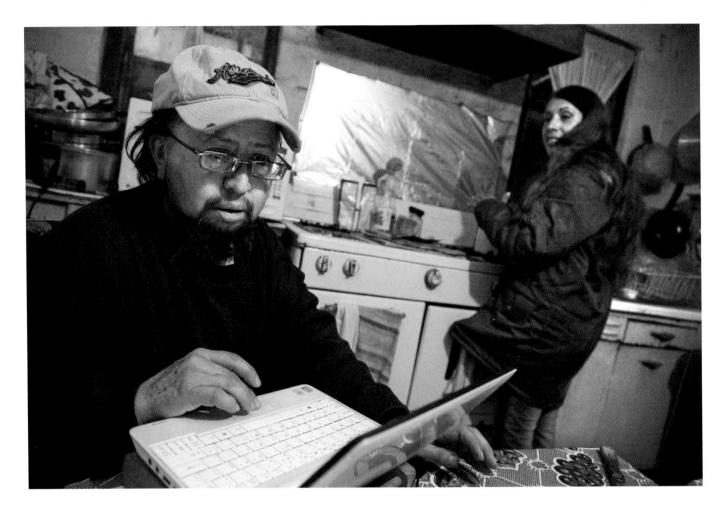

Mario and Diana take the weekend off at their house in El Real de Mina in Hidalgo,
the town where Mario was born sixty-one years ago.

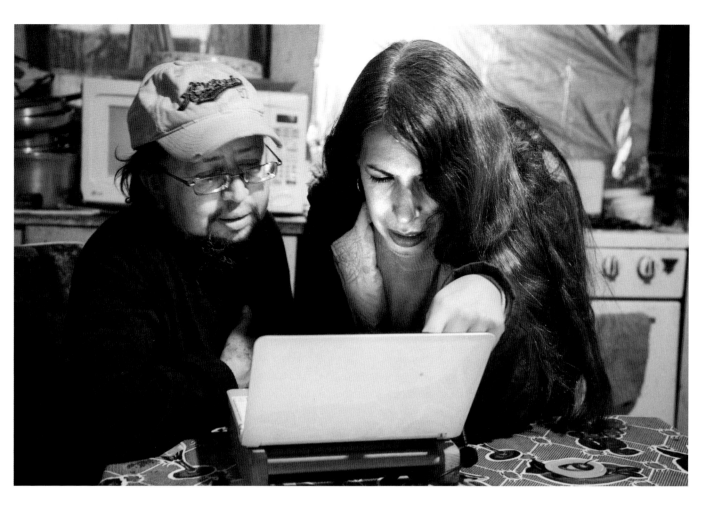

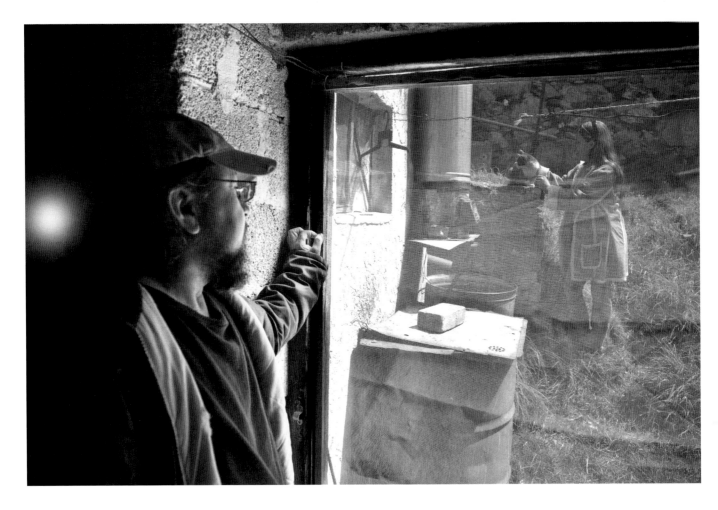

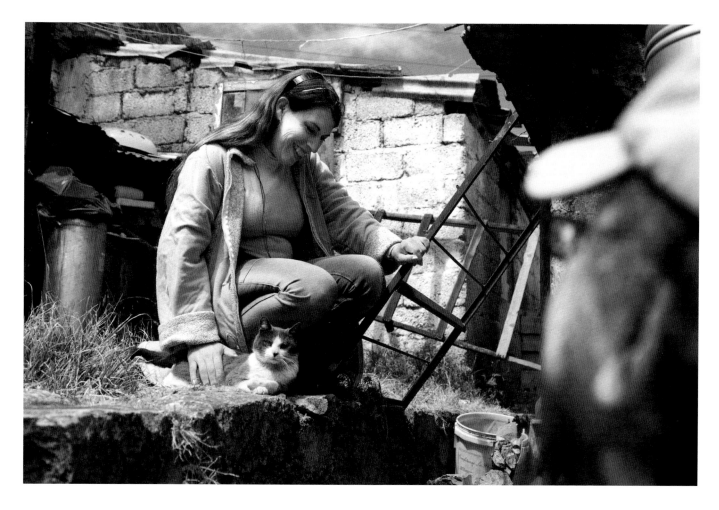

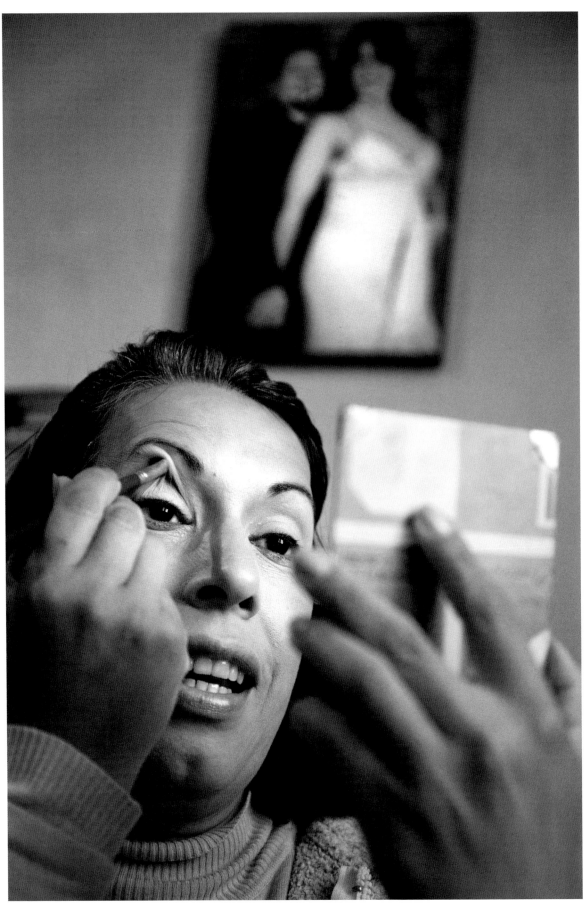

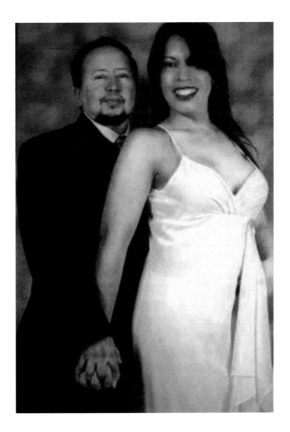

A portrait of Diana and Mario taken on May 17, 2008, the day of their wedding in Mexico City. As the first transgender couple legally married in Mexico, their wedding attracted national and international attention. Media outlets from all over the world covered their weddding. Photo courtesy of Diana and Mario.

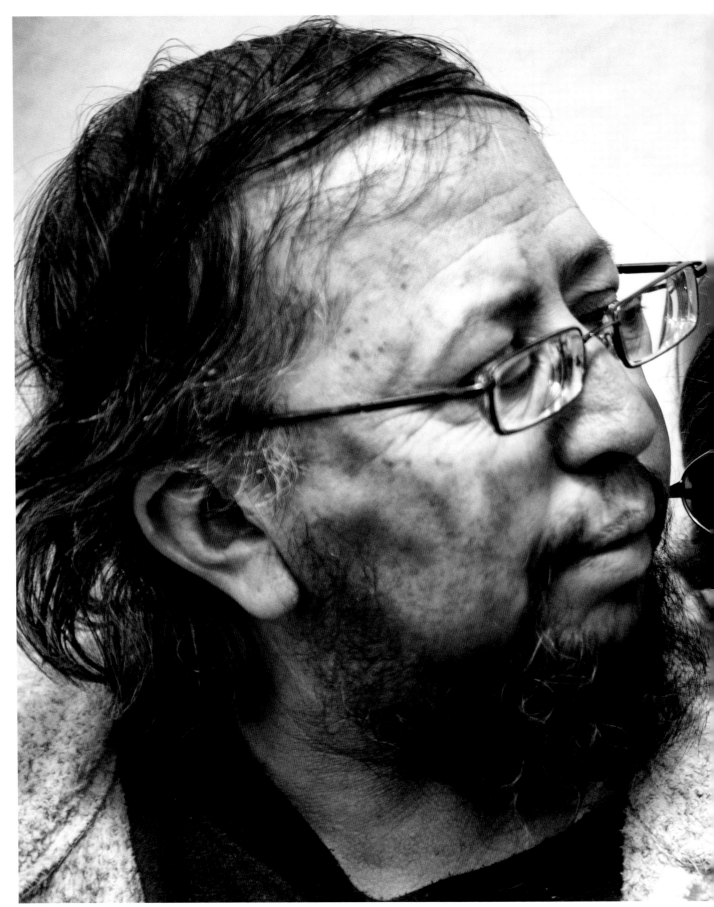

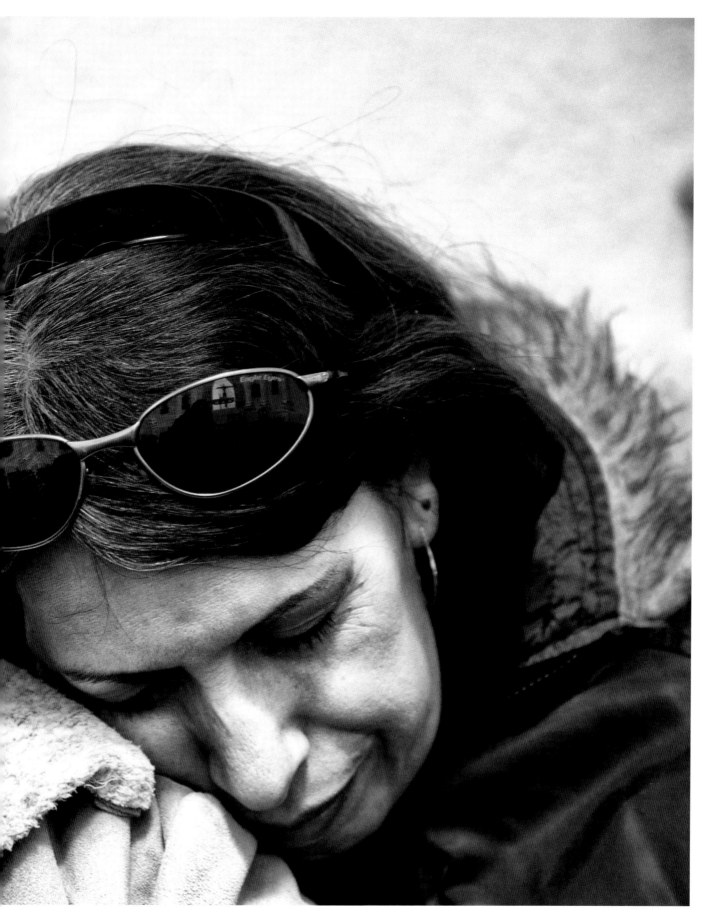

Himmel Reyes Lara

HIMMEL REYES IS A WELL-KNOWN TRANSGENDER ENTERTAINER WHO HAS SUNG ON TELEVISION AND TAKEN A NUMBER OF ROLES IN FILMS. FOR MANY PEOPLE IN THE TRANSGENDER COMMUNITY, HIMMEL REPRESENTS SUCCESS AND IS A SOURCE OF INSPIRATION.

Himmel was born Jimen Francisco Reyes Lara. Growing up, she learned that her father was bisexual. Her father's sexuality generated confusion in her early life.

Even as a little boy, Himmel self-identified as a homosexual. At an early age, Himmel fell in love and suffered because her love was not reciprocated. After unsuccessful romances, Himmel decided to change her look to one of a woman. She says, "I don't want to be a woman, I just want to look like one because I suffer less by being a woman instead of being a man . . . as I boy I even had a mustache, but I suffered much discrimination. [The men I liked] would tell me: how am I going to go out with you? And now, I can go out with guys, and they even hold my hand, and I feel very happy. But I am still a man. And in sex, I like my male organs, that is the power I have to satisfy."

Himmel had a big break when she was a teenager and was elected Mexico's Model (trans) of the year. She has participated in plays and movies and even hosted her own radio talk show.

"I suffered a lot when I was a boy because I had platonic loves. I started to change my look [into trans] and eventually ended up having relationships with those people, that's why I decided to take a woman's look."

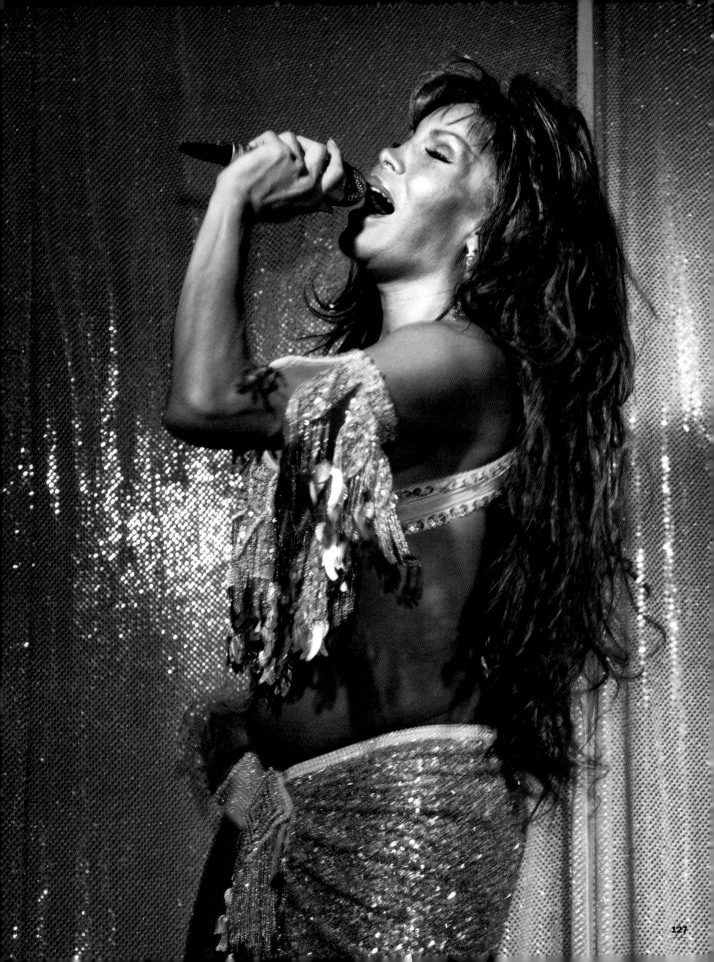

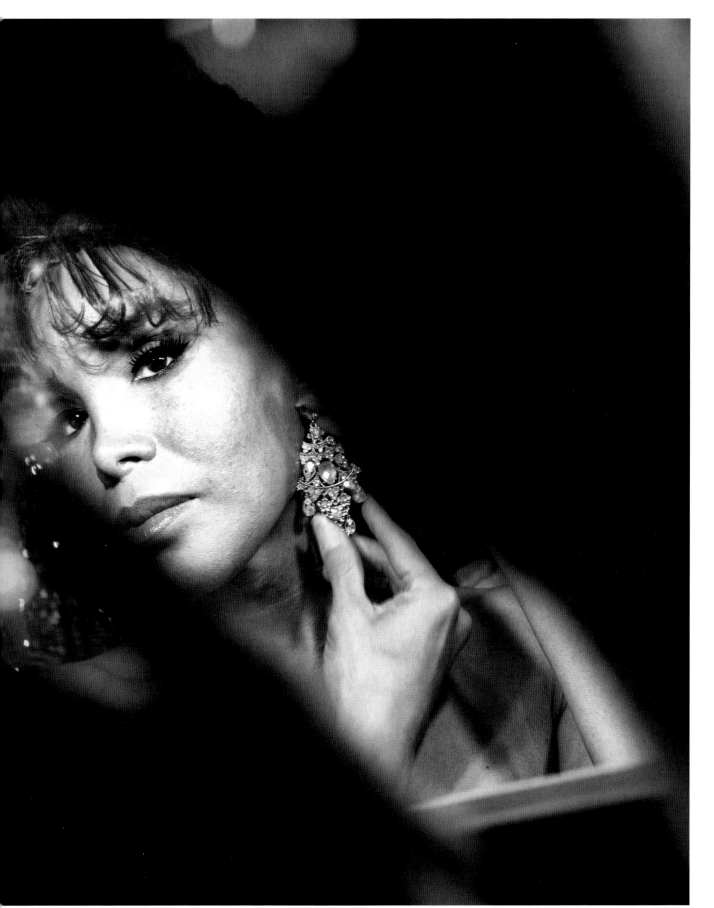

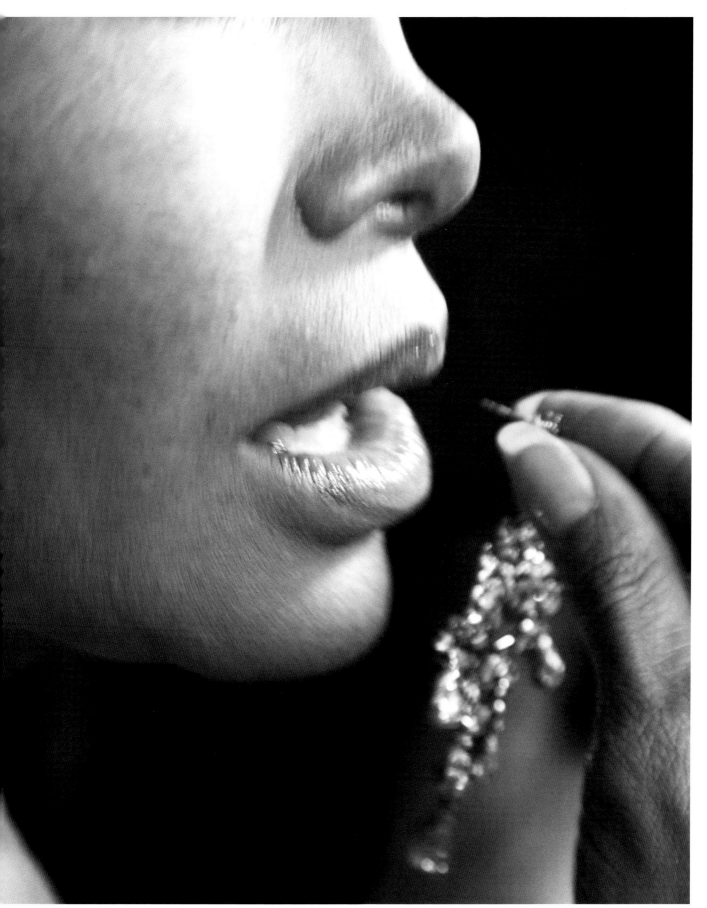

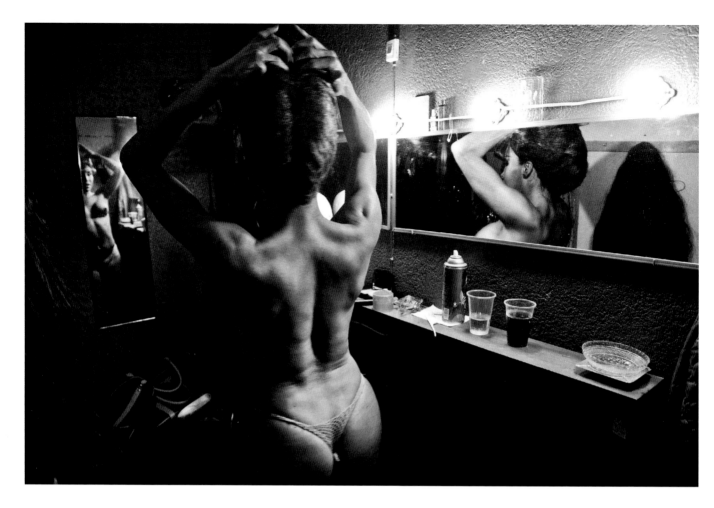

Himmel applying makeup and getting ready for a performance at Club Roshell,
a cabaret for transgender people in Mexico City.

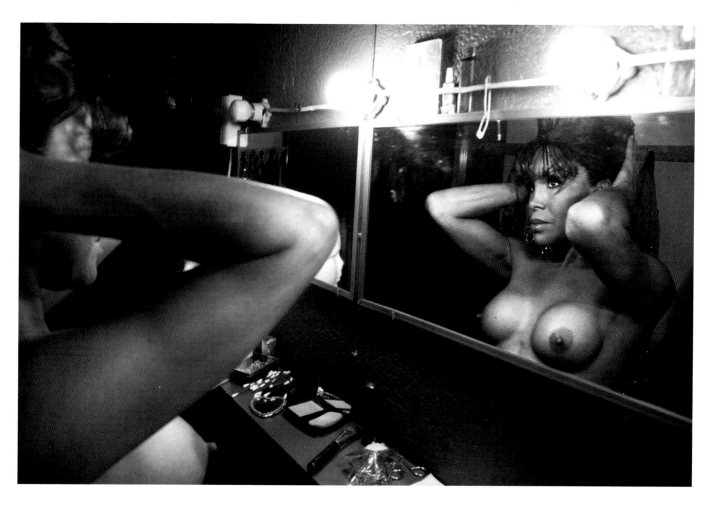

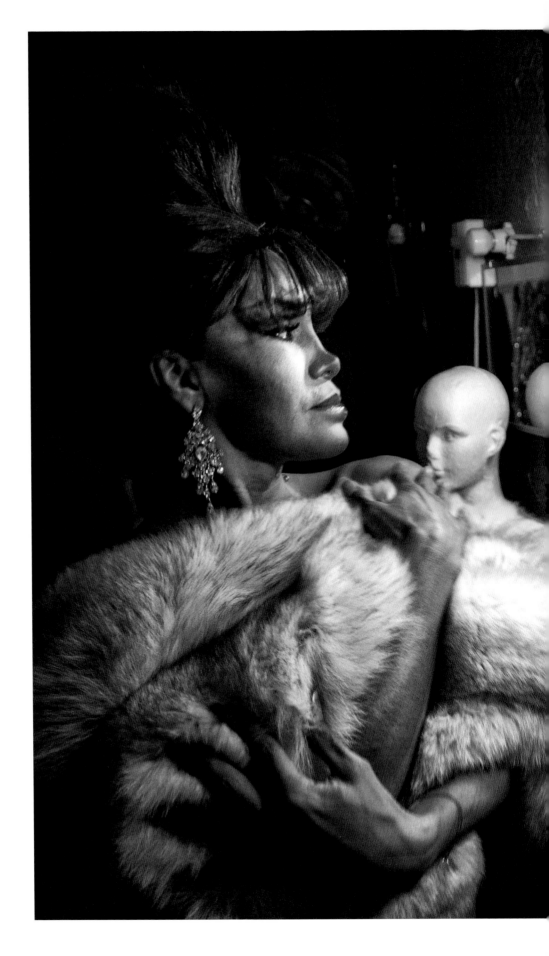

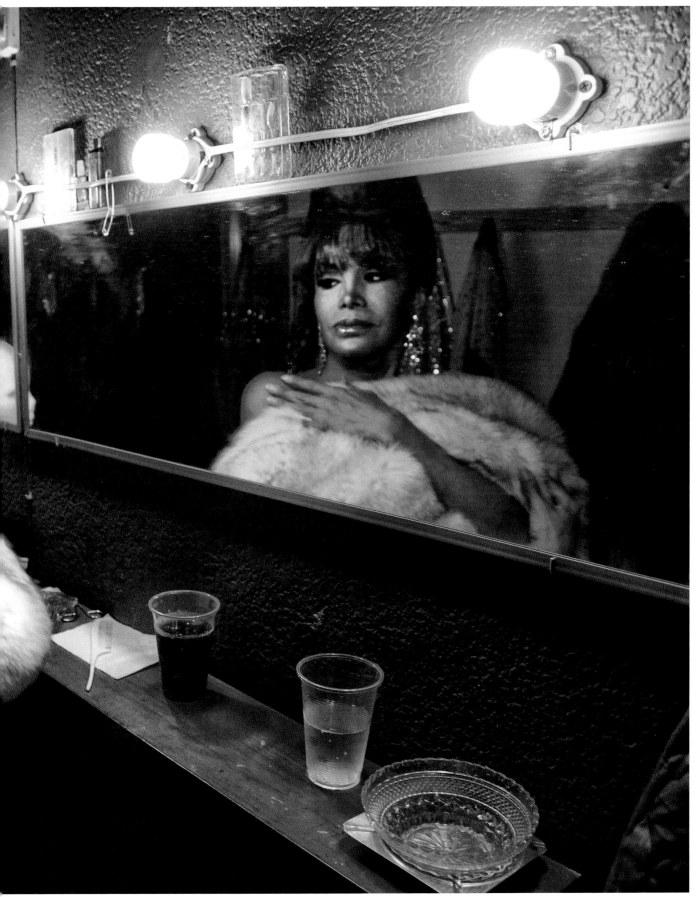

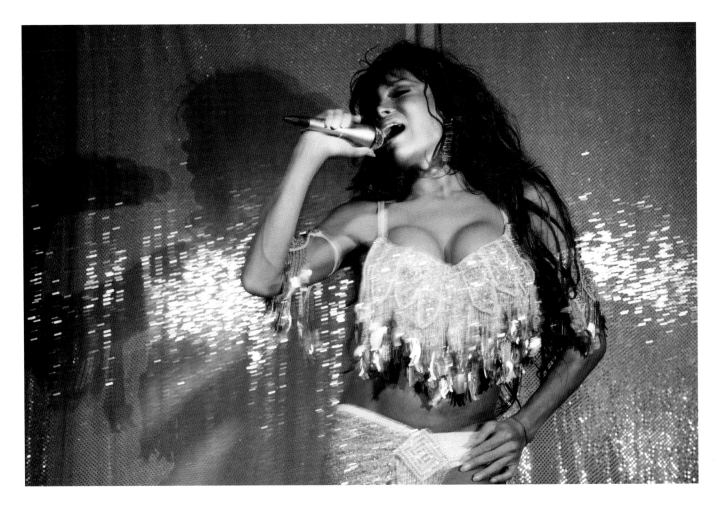

Himmel sings during her performance at Club Roshell.

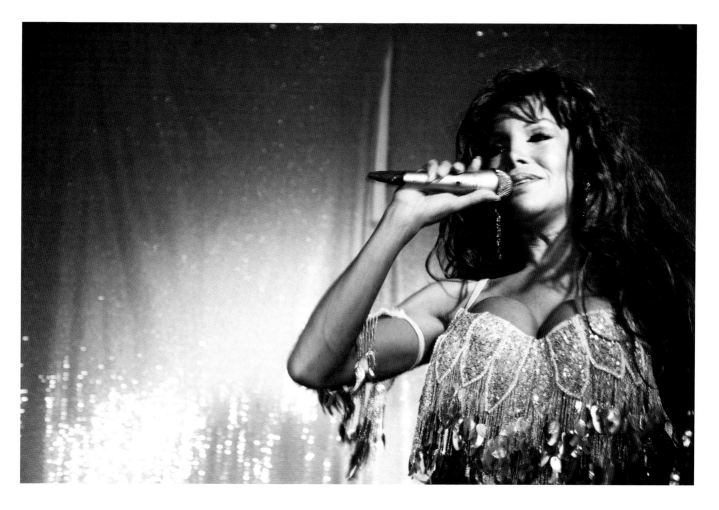

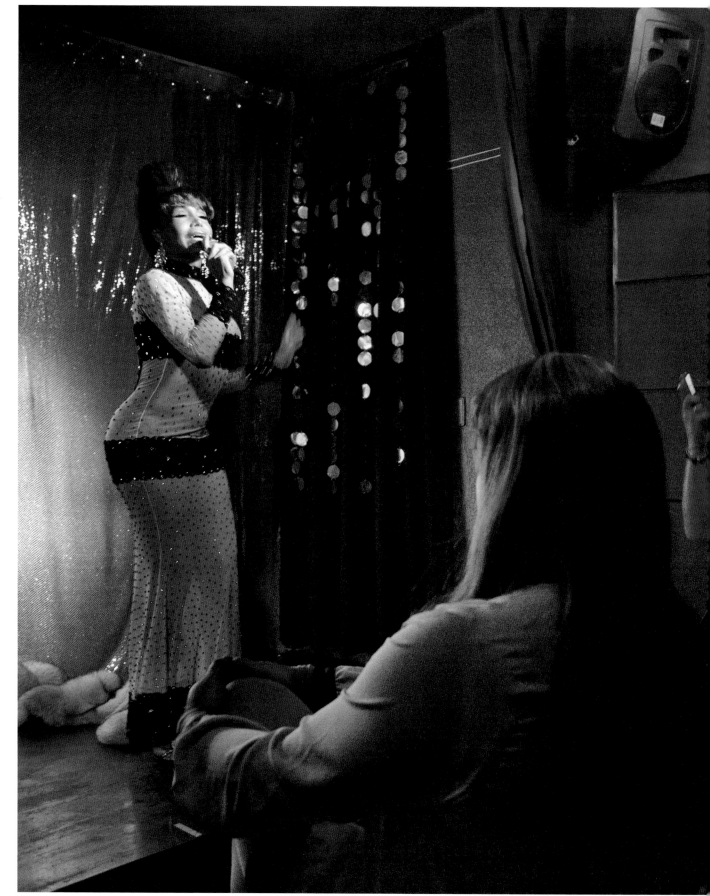

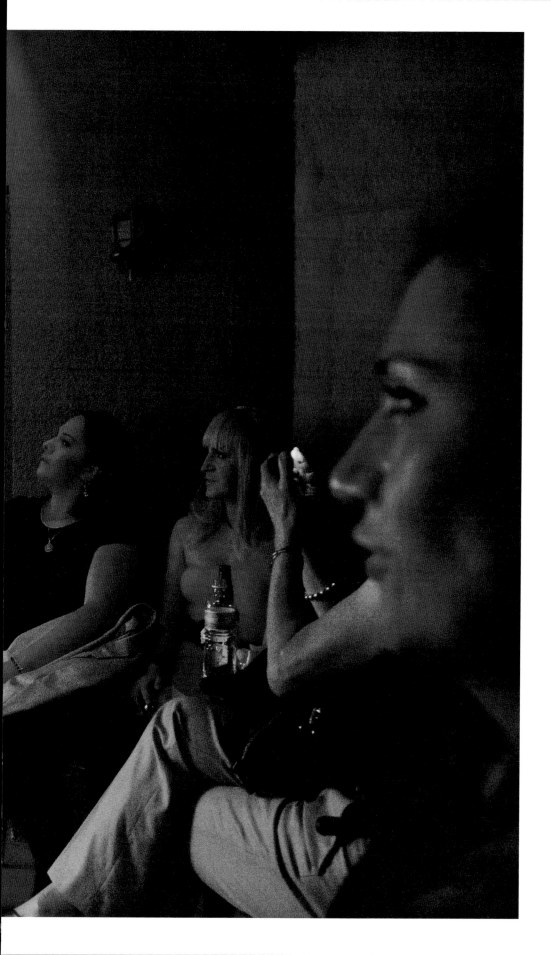

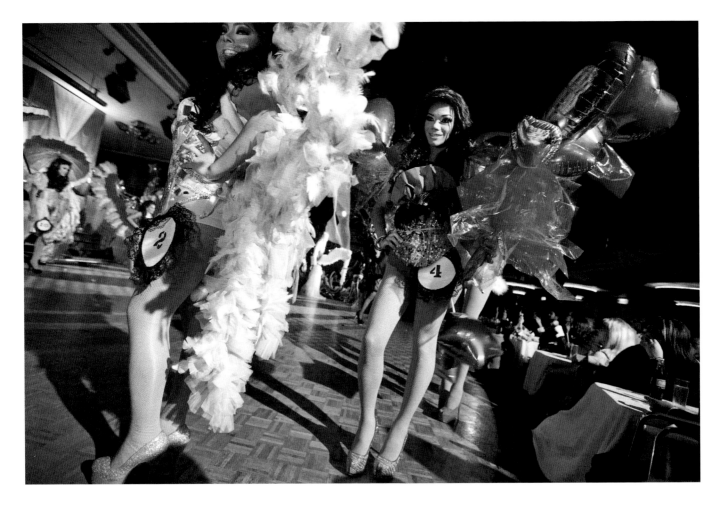

Election of Model of the Year 2013, an event that honors transgender models in Mexico. Himmel was the winner of the first Model of the Year competition. She was a guest of honor who presented the winner and finalists in the 2013 contest.

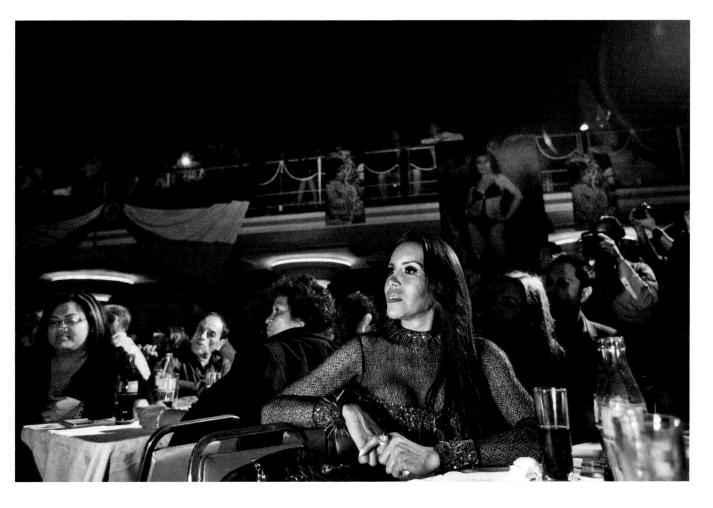

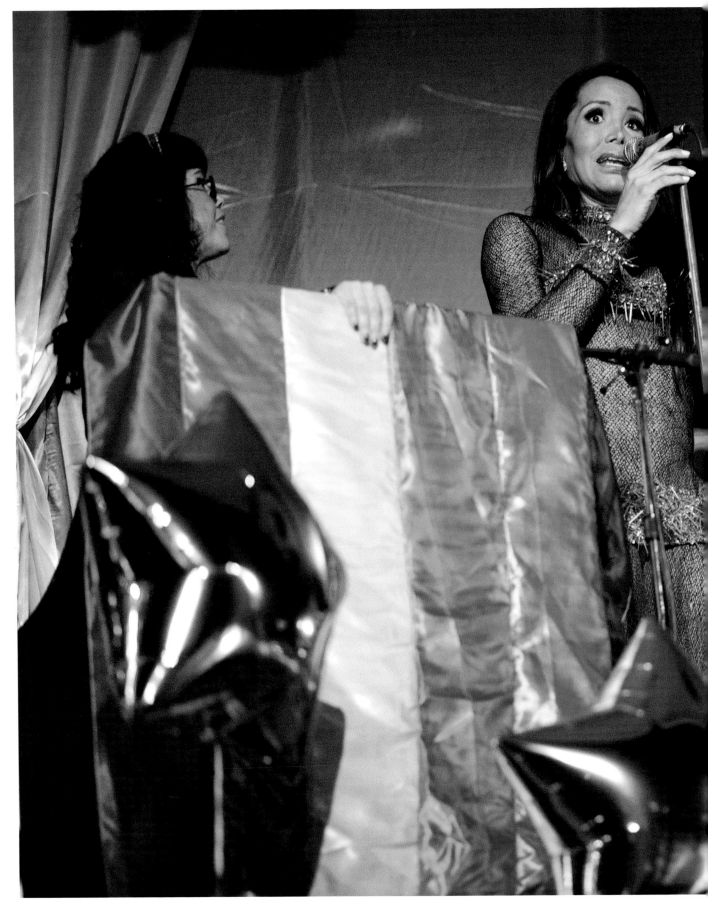

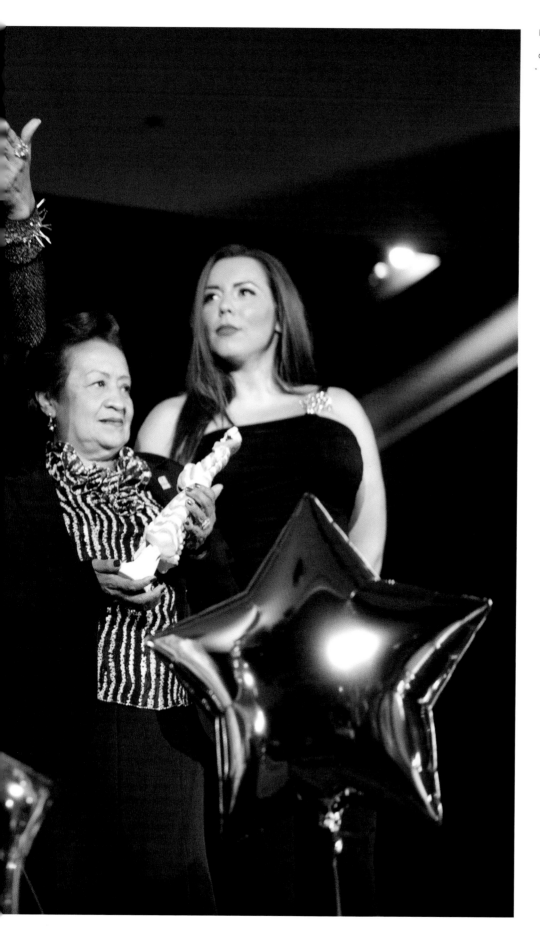

Himmel, with her mother standing next to her, receives an award at the Model of the Year 2013 ceremony recognizing her career as a model and entertainer.

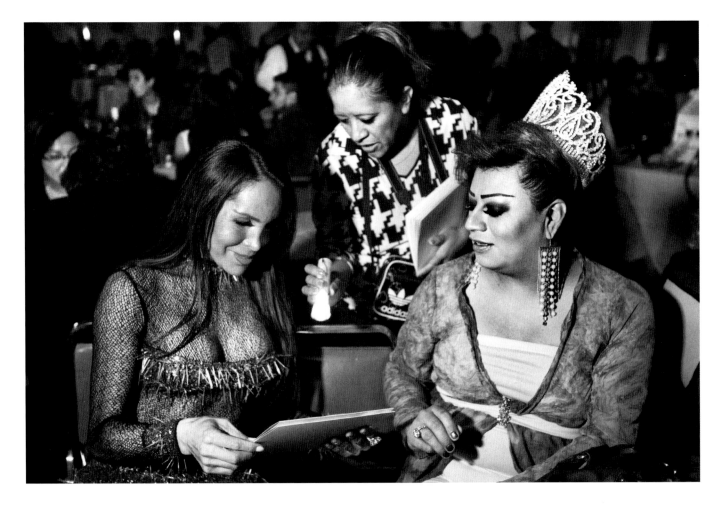

Himmel and a friend during the election of La Modelo del Año 2013.

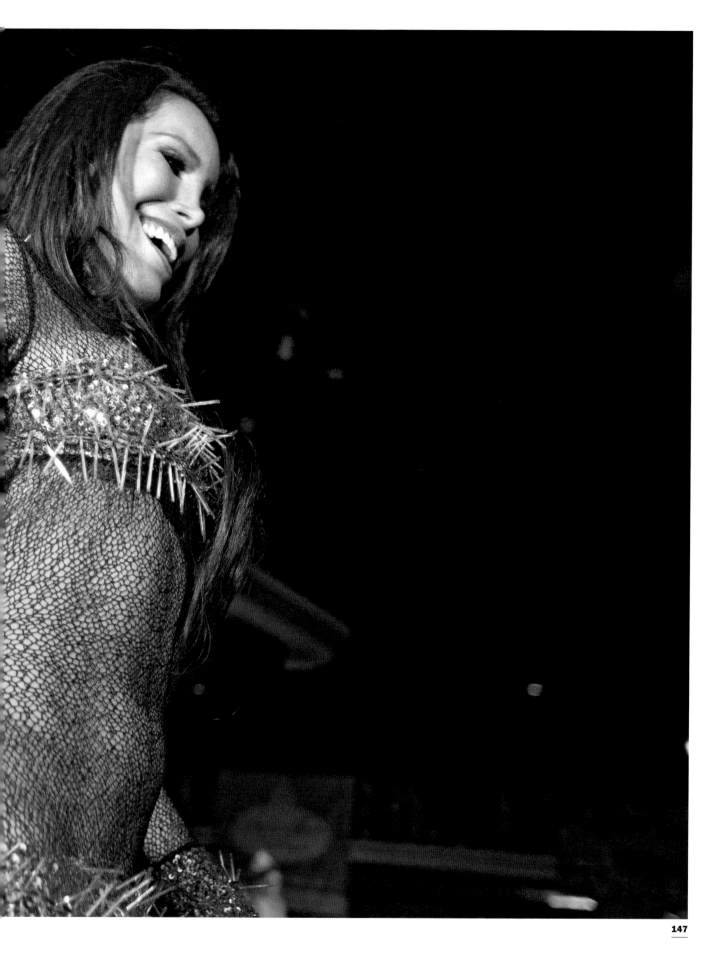

Jessica Marjane Duran Franco

A TWENTY-YEAR-OLD TRANSGENDER WOMAN FROM MEXICO CITY, JESSICA REALIZED THAT SHE WANTED TO LIVE AS A WOMAN AT THE AGE OF FIFTEEN, WHEN SHE FIRST BECAME SEXUALLY ACTIVE. SHE IMMEDIATELY TOLD HER FAMILY, WHO RECEIVED THE NEWS WITH MIXED EMOTIONS.

Jessica's mother, Ernestina, supported her wholeheartedly, as did her grandmother; she says, "My grandmother was very open and told my mum that she could see it coming, that one could tell." Her father broke off all contact with her. Jessica never lived with her father; he was an alcoholic and used to hit her mother until she threw him out. A year ago, Jessica "met him on the street while he was drunk. I told him that my name was Jessica and that I was transitioning," but he ignored her.

School was difficult for Jessica. Other students and teachers bullied her, saying she was responsible for her isolation. After taking two years off from high school to adapt to her new life, Jessica has returned to school. She has already been admitted to Universidad Nacional Autónoma de México (UNAM) and hopes to become a social worker in the transgender community.

Jessica has undergone hormone replacement treatment for several years. She has plans for sex reassignment surgery, but, as a student, the costs are prohibitive. She has postponed her plans until after she has graduated from college, when she hopes to be more stable financially.

Jessica is completely open about her gender identity, and she has been in a relationship with a twenty-three-year-old engineer, Luis Enrique Sanchez, for more than two years. From the first day they met, she told Luis that she was a transgender woman, and this has never proved to be an issue. Together, Jessica and Luis Enrique talk about having children in the future.

"My story is a fortunate one if it is compared to other transgender people who had to run away from their homes, have been killed or rejected for a job."

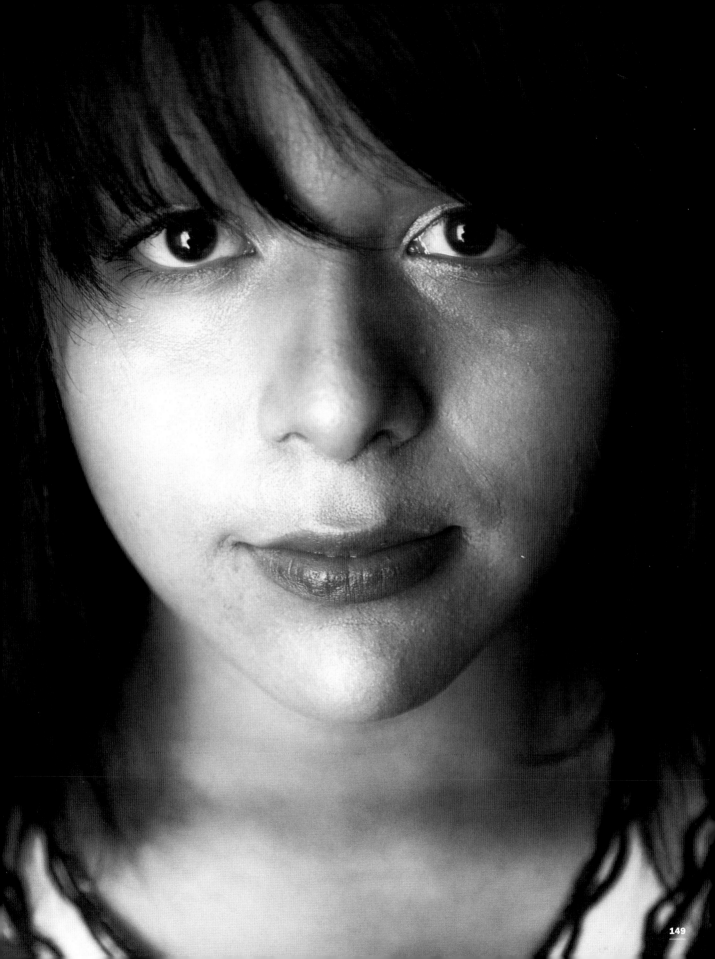

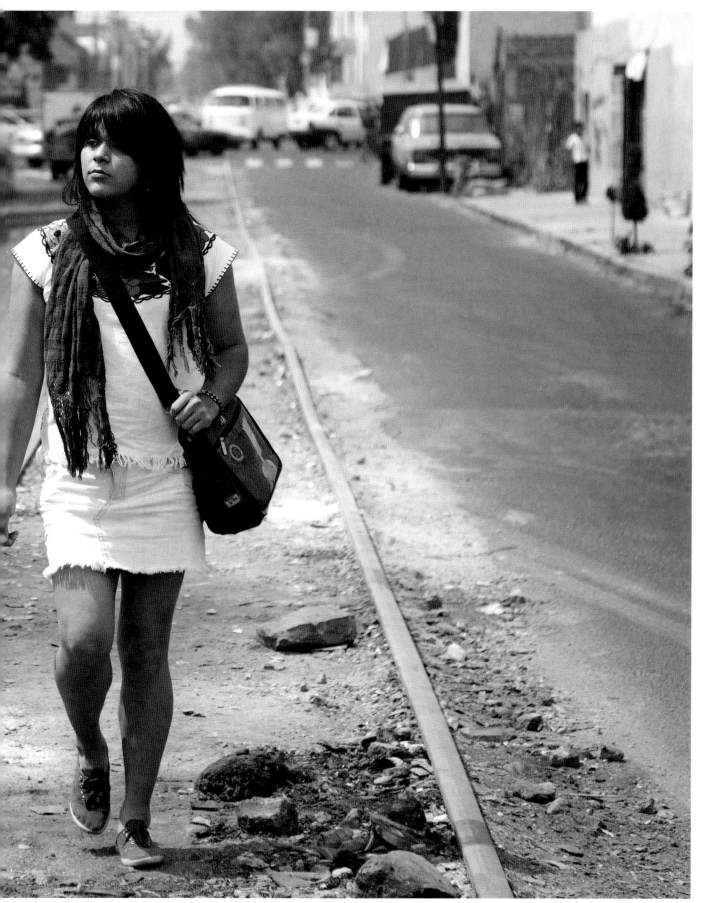

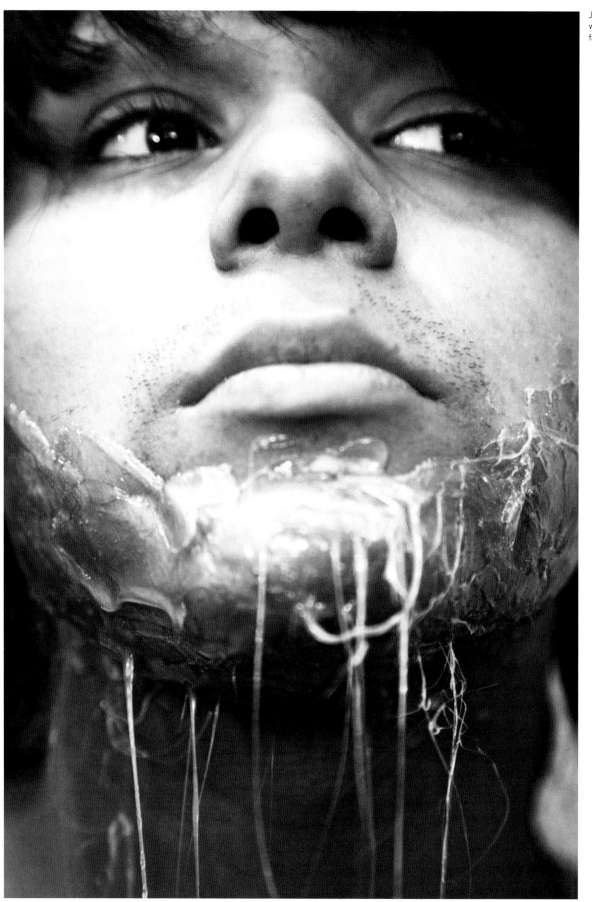

Jessica applies wax to remove her facial hair.

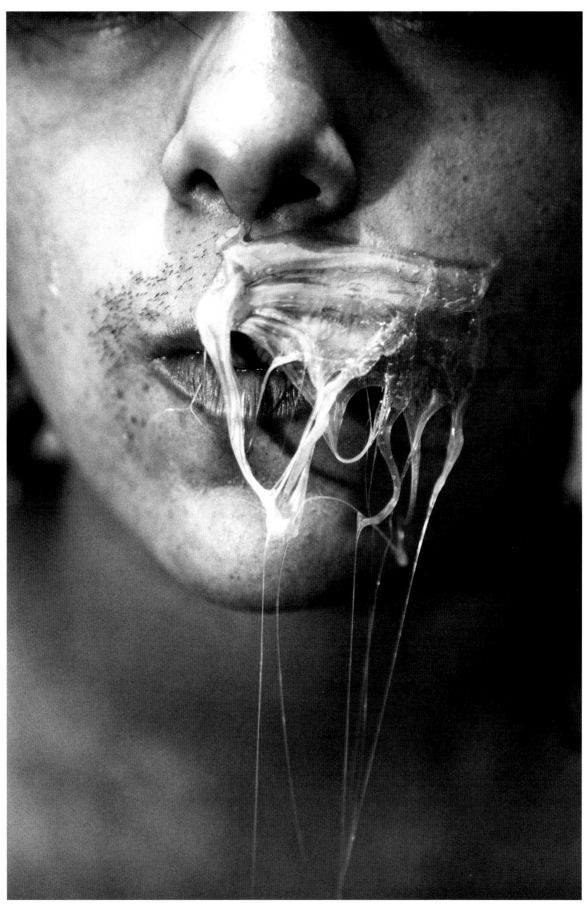

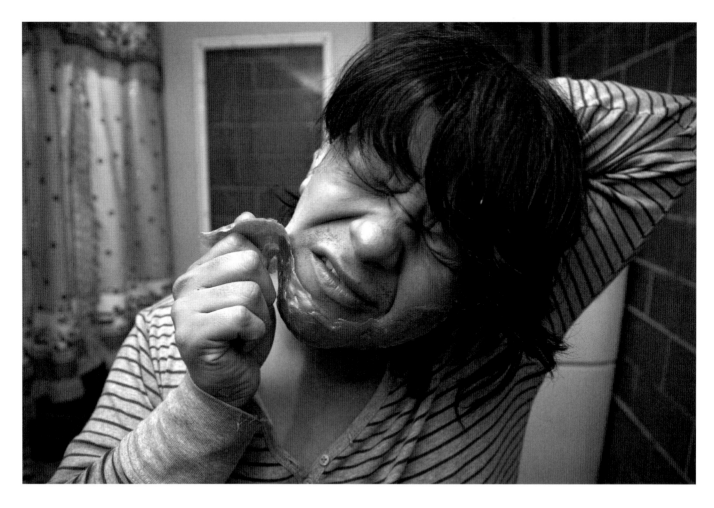

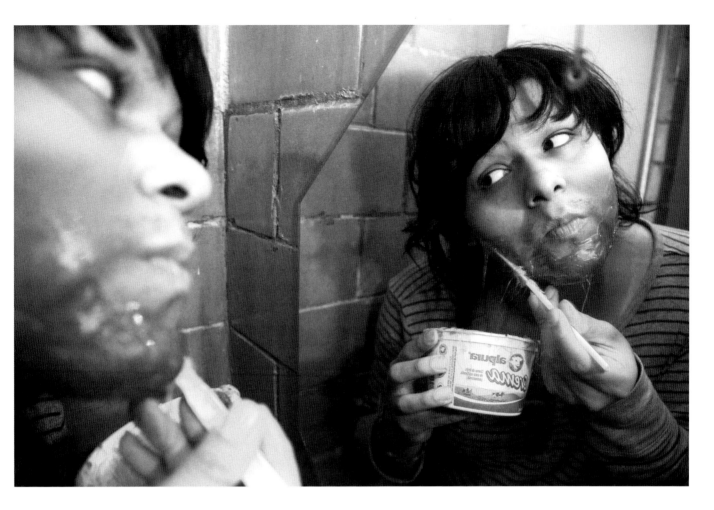

Due to hormone medication, Jessica grows less facial hair every day; nevertheless, she has to remove it once a week to enhance her feminine look.

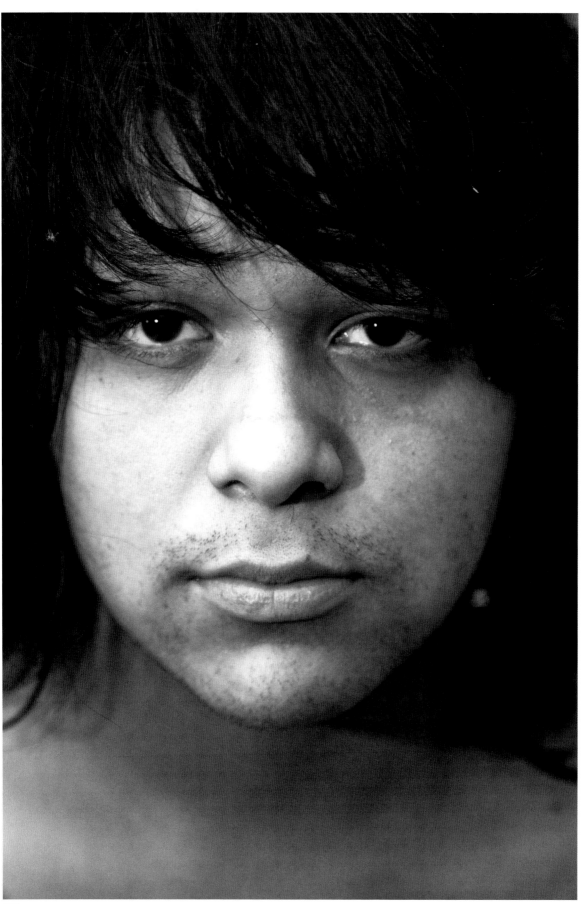

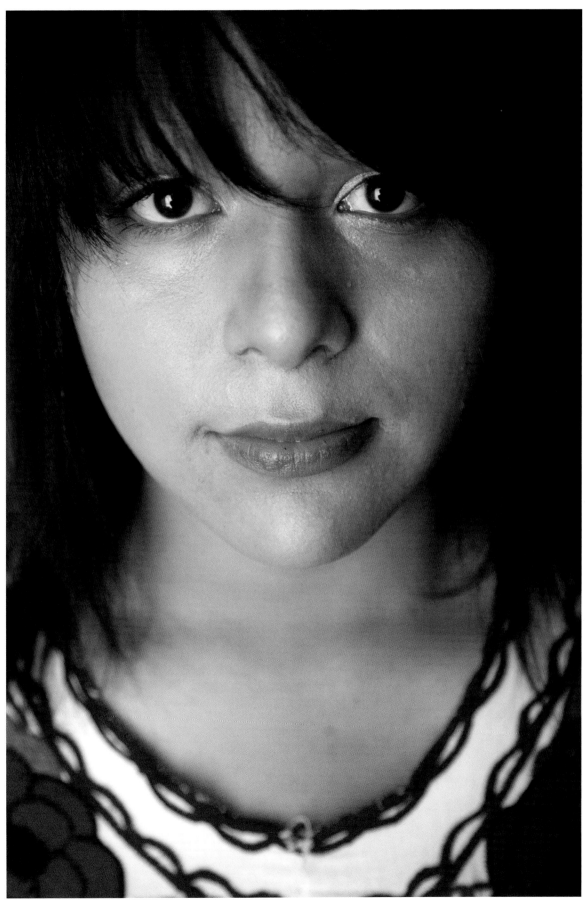

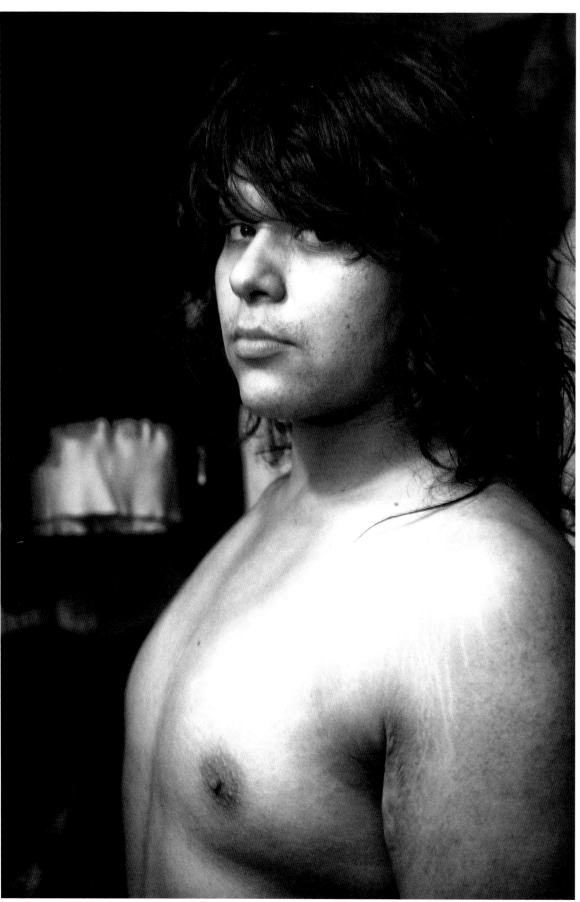

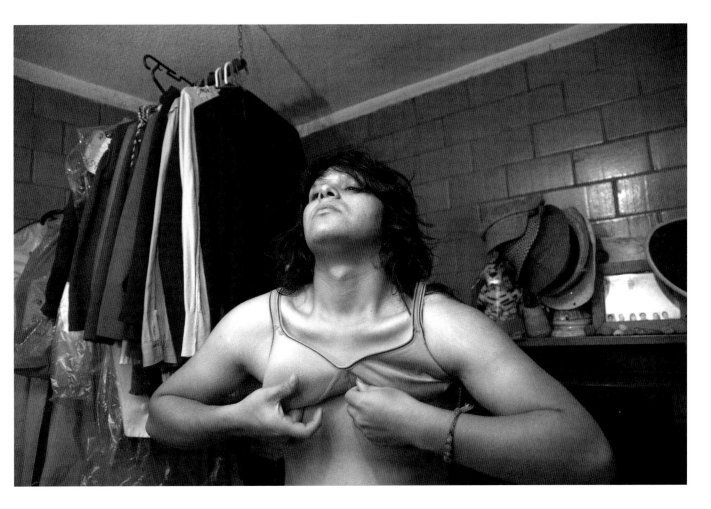

Jessica looking at herself in the mirror.

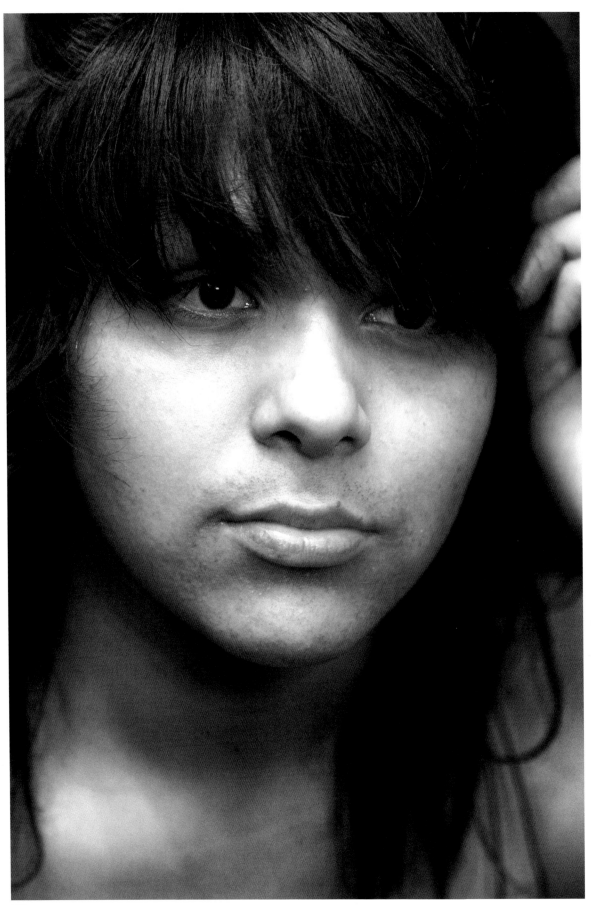

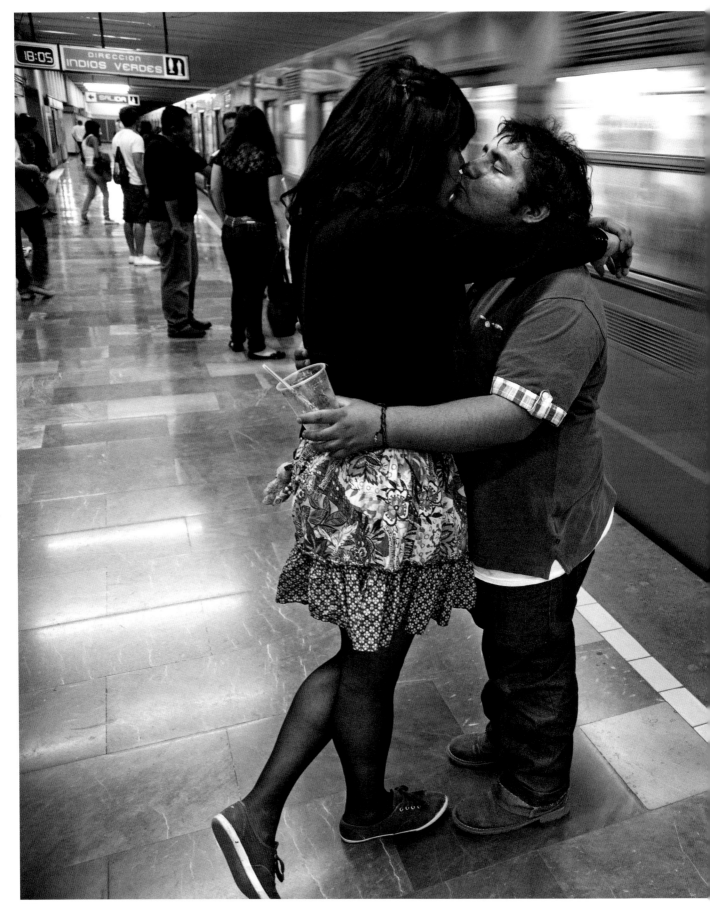

Jessica with her boyfriend, Luis Enrique.

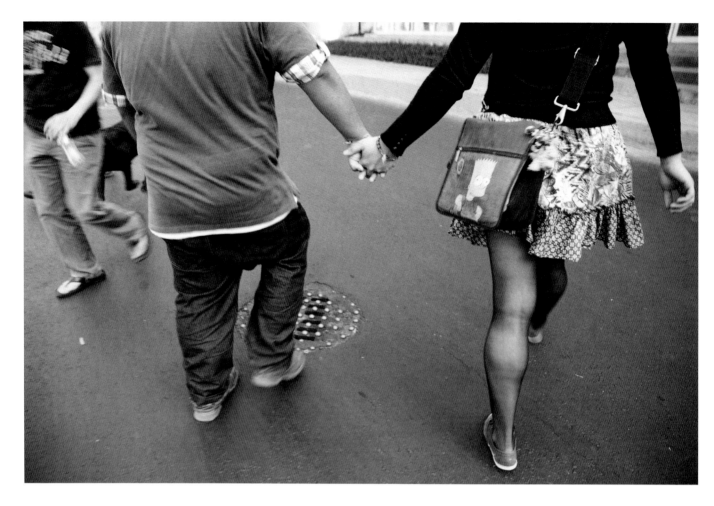

Jessica and Luis Enrique go out on a Sunday afternoon.

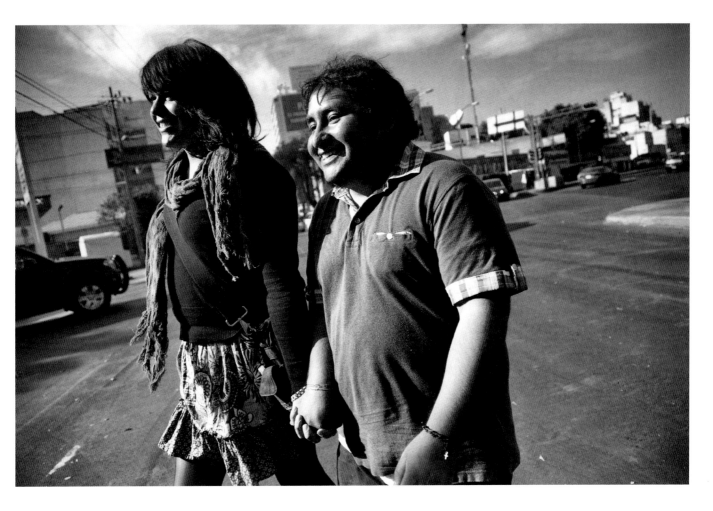

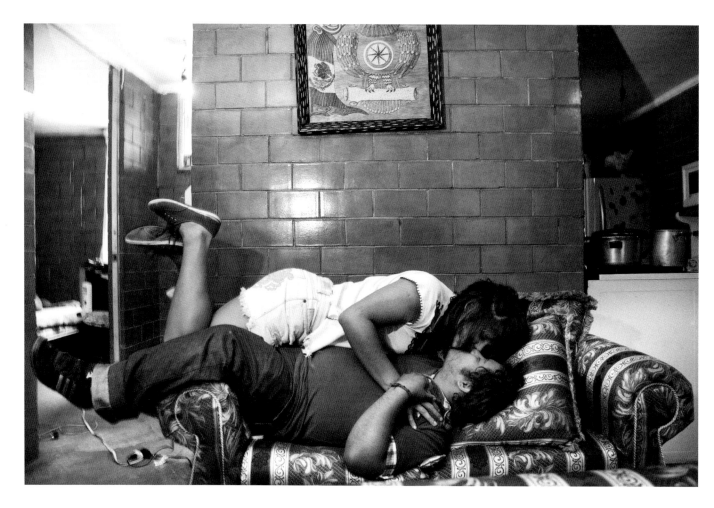

Jessica at her home during an intimate moment with Luis Enrique Sanchez, her boyfriend.

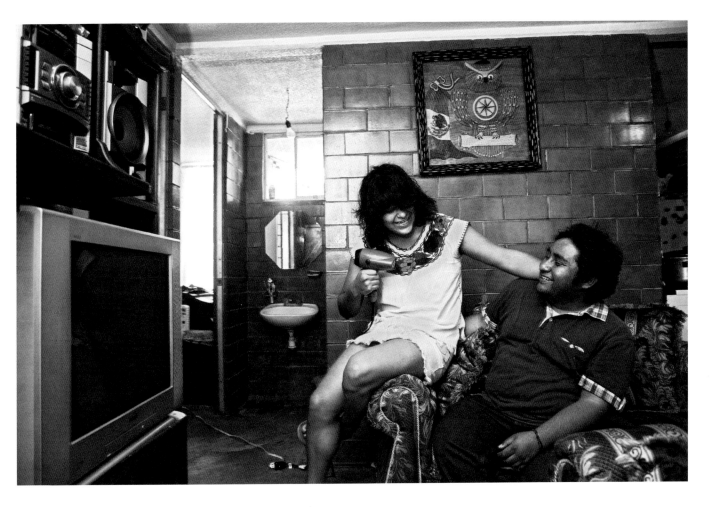

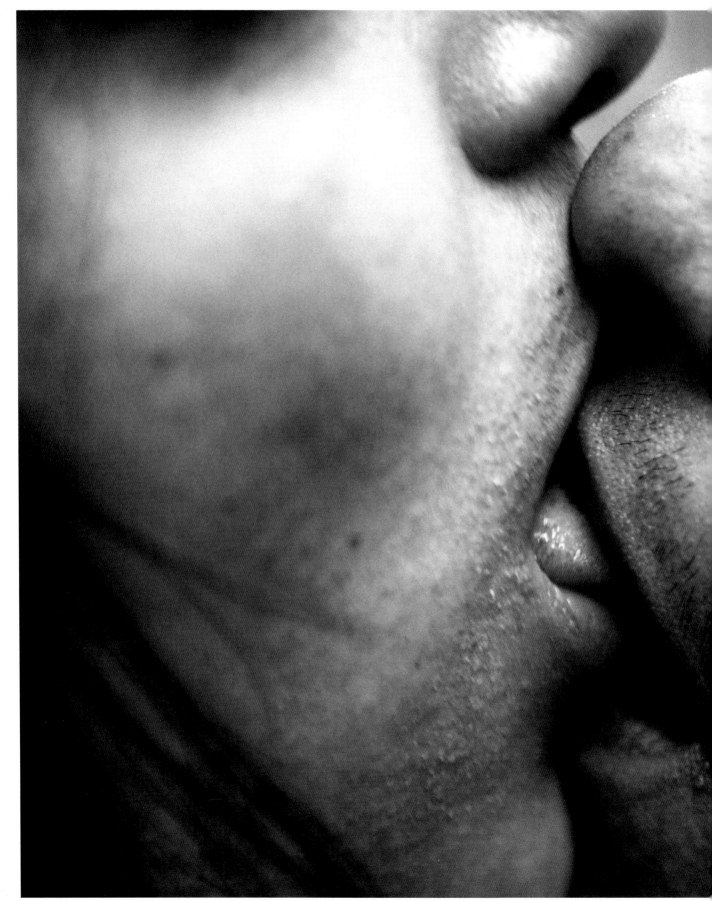

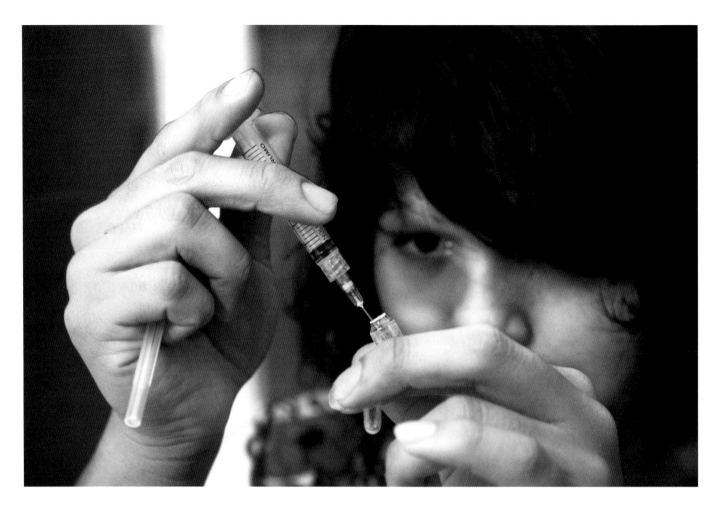

Jessica prepares the syringe with a dose of Cyclofemina, a progesterone with estradiol hormone.

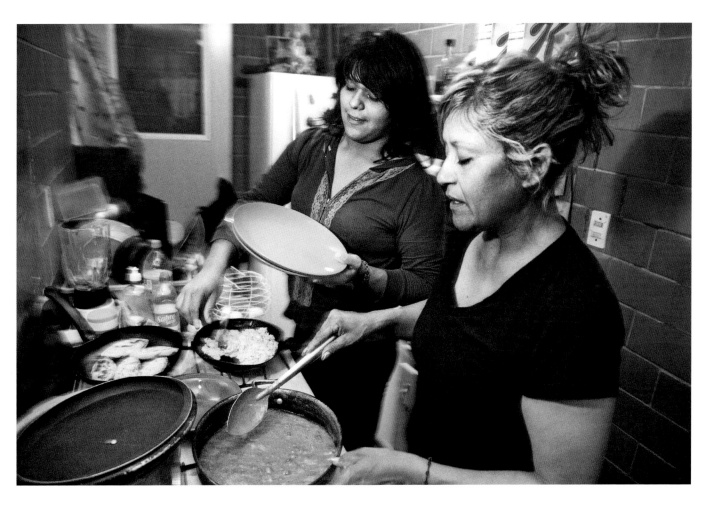

Ernestina, Jessica's mother, cooks while Jessica sets the table for lunch.

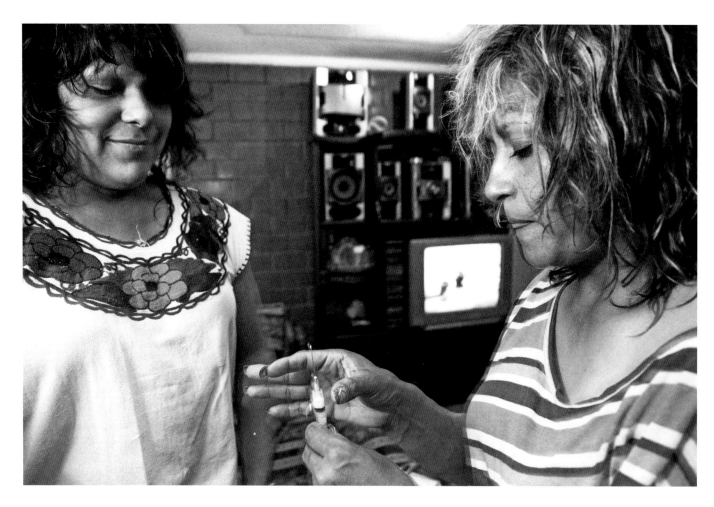

Ernestina, Jessica's mother, injects her with Cyclofemina. Although at the beginning
Ernestina worried for Jessica's future, she later became her daughter's best support.

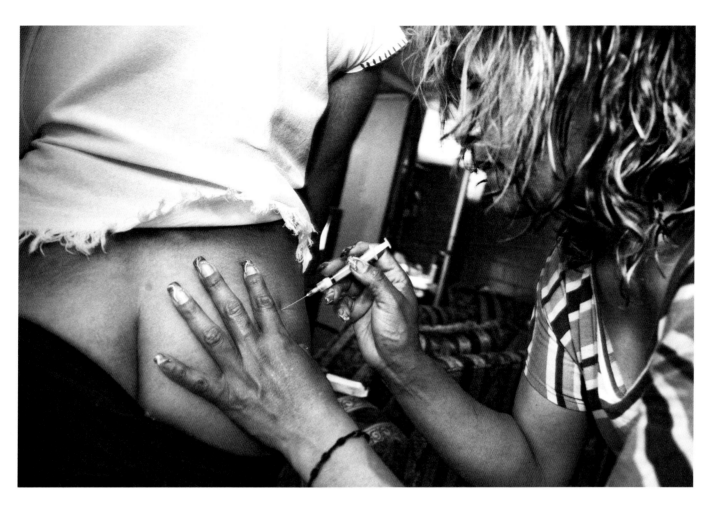

Jessica studies for an exam. After high school, Jessica expects to enter UNAM, Mexico's most prestigious university. She wants to be an advocate for the transgender community.

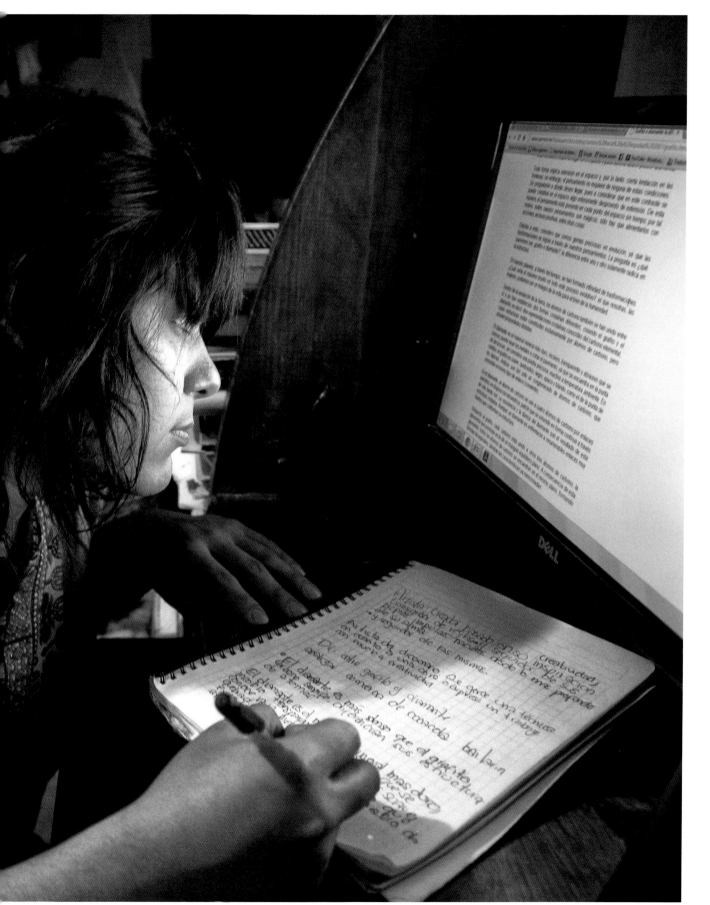

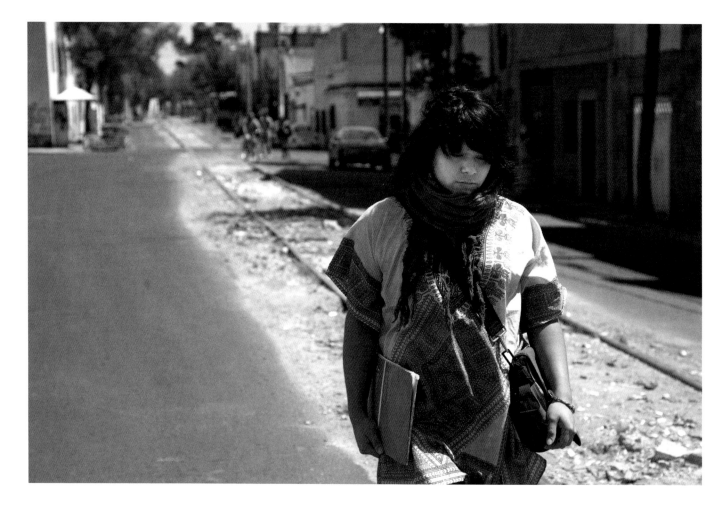

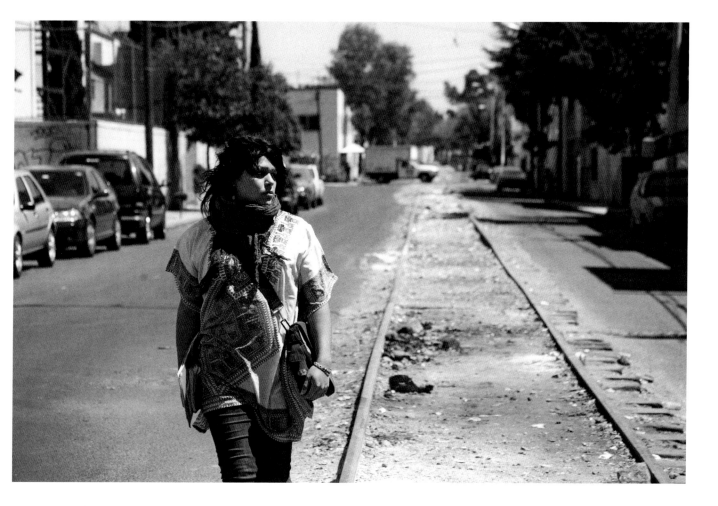

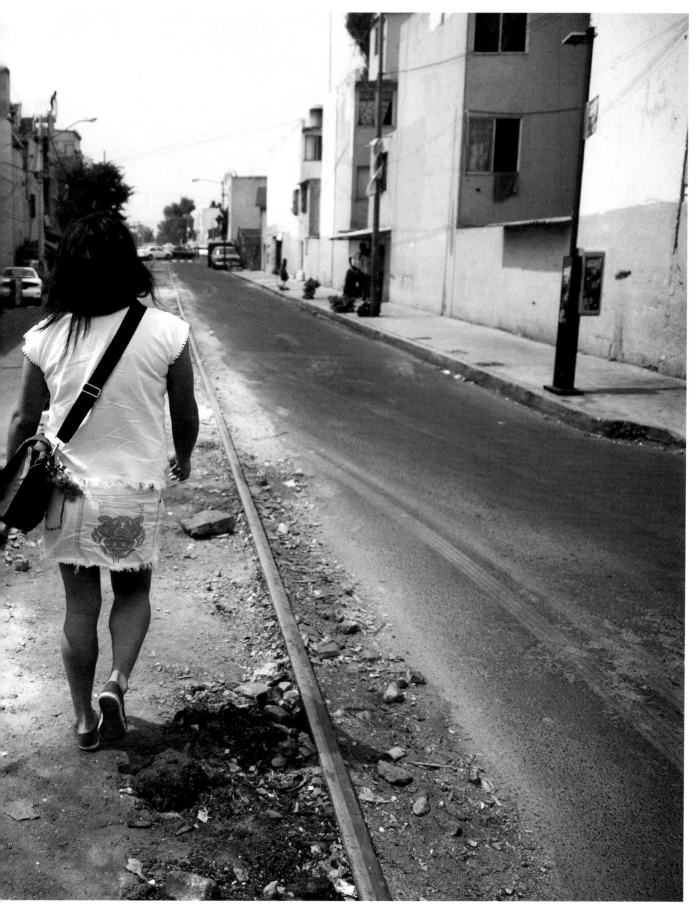

Acknowledgments

The photographs presented in this book were made possible by a commission from Jon Stryker: philanthropist, architect, and photography devotee.

This book was made possible in part by a grant from the

So many people helped me during the production of these images.

First, my gratitude goes to Angie, Génesis Rafael, Oyuki, Mario and Diana Laura, Himmel, and Jessica Marjane for opening their lives to me and to others. I would like to express my most profound admiration for their *coraje*.

I would like to thank Robin Savinar, Tarek Milleron, Maria Alejandra Perez, Mathieu Asselin, Saneta Devuono-Powell, and Rebecca Bauen. They helped me at the beginning when the idea of this project was gestating. Warm discussions and different perspectives were invaluable to foresee the direction of this visual exploration.

During the time I spent working in Mexico, I received unconditional support from friends and colleagues. My gratitude goes to Nicole Holmes, Edson Bastidas Hernandez and Lichy Estrada Chavez, Teresa Villarreal, Ximena de la Macorra, Alejandro Gonzalez Medina, and Agata Lanz. There was always a place for me at their table, and even a couch to crash on a few nights during the months I worked.

I would like to extend my gratitude as well to the following people who in one way or another collaborated with me during the process of photographing for this book: Mirna Pulido, Marisol Shane, Karla Ivon, Estefanía Daniela, Wendy Selene, Ninel Lizeth Avila, Adriana Tapia, Magaly Bobadilla, Melken Mejia, Valeria, Andrea, Ivette Avila Ramirez, Monce Antunez Guerrero, Miriam Guzman, Kardasha Caballero, Pamela Resendiz, Mara Sofia Mondragon, Natalia Anaya, Trixie Ivette, Alix Rojas, Roshell Terranova, Sofia I Gonzalez, Nidia Argelia Fabela Marín, Alex Mejia, Diego Najib Herrera, Dr. Tirso Clemades, Levi Rodrigo Zurroza Calva, Melani Escalona, Azul, Sandra Lety, Saul Ivan Lopez Arzate, Emilio Ricardo Gutierrez Vasquez, Arturo Monroy, Julieta Calderon Becerril, Quetzally Medina, Gabriella Gallegos, Yadira Escobar Nuñez, Joanna Paula Garcia Espinosa, Leticia Velazquez Hernandez, Ernestina Franco Hernández, and Luis Enrique Sanchez Amaya.

Special thanks to Angie Rueda Castillo for her kindness. Angie's help was indispensable to create a network in the trans community of Mexico City.

To Rocio Suarez and the *Centro de Apoyo a las Identidades Trans* in Mexico. Rocio and her team work hard to prevent HIV and are very inspirational.

My deepest thanks go to Jurek Wajdowicz, Lisa LaRochelle, and Emma Zakarevicius at EWS. Long before I started to photograph in Mexico, Jurek believed that these stories were very important to tell and that we all could learn from them. His guidance was essential to me.

Finally, thanks to Mora and Clementina for their inspiration.

—Kike Arnal

*The Arcus Foundation is a global foundation dedicated to the idea that people can live in harmony with one another and the natural world. The Foundation works to advance respect for diversity among peoples and in nature (www.ArcusFoundation.org).